IMAGES
of America

EARLY
GLENDALE

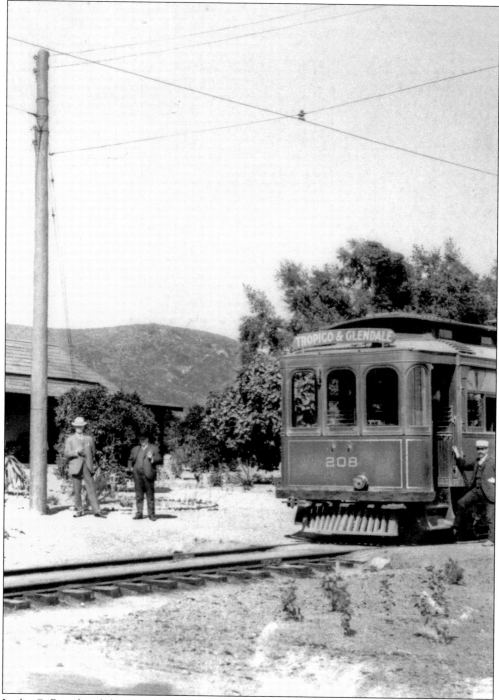

Leslie C. Brand and the Huntington Land and Investment Company purchased the former Bliss Ranch north of Glendale (which contained the old Sepulveda adobe shown to the left) and created a tourist destination called Casa Verdugo. The Pacific Electric northern terminus is shown here c. 1905 with train car No. 208 readying to depart south to Glendale and then on to Tropico. (Courtesy of the Special Collections Room, Glendale Public Library.)

IMAGES
of America

EARLY
GLENDALE

Juliet M. Arroyo

ARCADIA
PUBLISHING

Published by Arcadia Publishing
Charleston, South Carolina

Printed in the United States of America

Library of Congress Catalog Card Number: 2005922452

For all general information contact Arcadia Publishing at:
Telephone 843-853-2070
Fax 843-853-0044
E-mail sales@arcadiapublishing.com
For customer service and orders:
Toll-Free 1-888-313-2665

Visit us on the Internet at www.arcadiapublishing.com

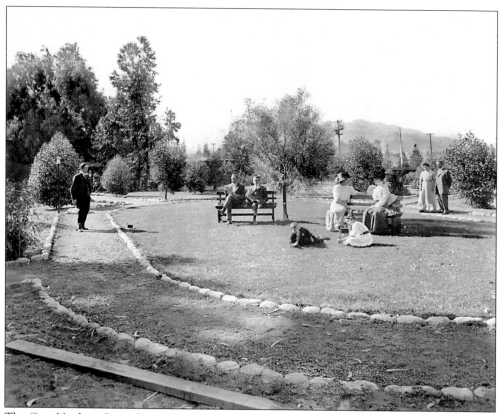

The Casa Verdugo Spanish restaurant and gardens, shown here in 1910, provided a picturesque setting overlooking the Glendale's valley and beyond. The attraction served as the destination of the Pacific Electric streetcar system since nothing was found in northern Glendale at the time. (Courtesy of the Special Collections Room, Glendale Public Library.)

CONTENTS

ACKNOWLEDGMENTS

I would like to acknowledge certain people, research facilities, and local historians that helped make this publication possible, including the numerous unknown donors of historical photos. I would like to especially thank George Ellison, library assistant with the Special Collections Room of the Glendale Public Library, for guiding me through extensive materials in the room, and to Charles Wike, community relations manager with the Glendale Public Library, for providing access to historical photographs. I would like to acknowledge the work of previous Glendale historians, including John Calvin Sherer, Carroll W. Parcher, Barbara Boyd, E. Caswell Perry, and the history writers of the *Glendale News-Press*, including George Goshorn, Ellen Perry, and Katherine Yamada. I would like to thank Mike Lawler for his knowledge of Crescenta Valley, Charlie Fisher for his knowledge of Julio Verdugo, and Vic Pallos, public relations specialist with the Glendale Unified School District. I would like to thank the Seaver Center for Western History Research, California State University Northridge, San Fernando Valley History Project, Los Angeles Public Library, California Historical Society, Verdugo Heritage Association, and the Glendale Historical Society. I would also like to thank Robert F. Arroyo for his knowledge of early California history, Antoinette Smit, friend and longtime Glendale resident, and Bruce Petty and Patrice Jansen for their support.

INTRODUCTION

Glendale history starts with the vast Rancho San Rafael, one of the first three ranchos given to former Spanish soldiers for cattle ranching. Jose Maria Verdugo received this land grant in 1784 and passed it on to his only son, Julio, and daughter Catalina when he died in 1831. Julio had several children, but Catalina remained unmarried and childless. One of Julio's sons, Teodoro, built an adobe in the area for his aunt Catalina around 1861 or earlier. It still stands today. In 1861, Julio and Catalina divided the Rancho San Rafael between them with Catalina taking the northern portion that included Rancho La Canada, and Julio taking the southern portion. Beginning in 1850, American expansion westward into California was too strong for the Verdugo family to retain their original Rancho San Rafael. American settlement significantly increased beginning in 1883, with easy rail transportation to the area named Tropico. Various settlements were found throughout the old Rancho San Rafael. Two of those settlements were forward thinking and thus recorded town sites in 1887 for the towns of Glendale and Tropico. Remote settlements founded in this period included La Canada and La Crescenta. The first name given to the settlement of the lower valley was Riverdale. Glendale developed as a small town site along an early Union Pacific train line running up Glendale Avenue. Over-speculation led to a depression in the 1890s that didn't end until the turn of the century, when population growth slowly picked up speed as the migration into California continued. As the settlements of Tropico and Glendale became better established, churches and schools followed. The arrival of Henry Huntington's Pacific Electric streetcar line through Glendale's valley created scattered residential neighborhoods mostly for workers in Los Angeles. In 1906, the expanding town of Glendale incorporated as the first city among the various settlements. The area was small but expanded tremendously through annexations up to the 1920s. By 1912, Brand Boulevard was the bustling hub of Glendale and served as the city's main street. The smaller town of Tropico to the south decided to incorporate in 1911, with San Fernando Road serving as its commercial center. In 1918, Glendale annexed the city of Tropico and continued to prosper during Southern California's boom in the 1920s, which established the physical form and suburban character of the city that remains today. Glendale, like the rest of the country, suffered during the Great Depression, but by the end of the 1930s activity again resumed. In 1939, the city produced a movie-quality promotional film about the efficiency of its government, called *Glendale on Parade*.

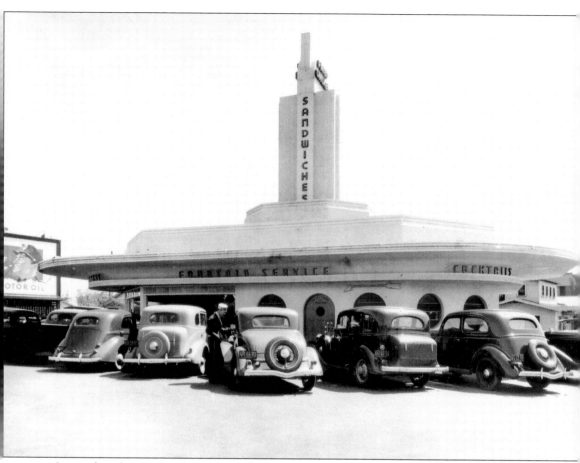

Located at the corner of Colorado Boulevard and Glendale Avenue, Henry's, shown here c. 1933, was one of Southern California's early drive-up restaurants with "car hops" that brought your meal to your car. (Courtesy of the Special Collections Room, Glendale Public Library.)

One

Rancho de los Verdugo
1784–1871

The Verdugo family is one of Alta California's oldest families. As a young man, Jose Maria Verdugo enlisted in the Spanish army and was part of Spain's colonial expansion from Loreto, Baja California, north into Alta California. He served the Mission San Gabriel, where his only son and several daughters were born. Wishing to retire to his own land to raise both his cattle and his family, Jose Maria asked the Spanish governor, Pedro Fages, for permission to establish a rancho in the territory he called La Zanja. In 1784 he received that permission. In exchange, he was obligated to raise cattle and do no harm to the Indians or the Mission San Gabriel.

Jose Maria Verdugo's territory was the valleys, streams, and mountains between the Los Angeles River, the Arroyo Seco, the boundary of the Mission San Fernando on the west, the boundary of the Mission San Gabriel on the east, and the valley to the north. The western boundary was confirmed when the San Fernando Mission was established in 1797. Jose Maria became ill and died in 1831, passing on his land, which he titled *San Rafael* after his favorite saint, to his only son, Julio, and his unmarried daughter, Catalina. When Mexico won its independence from Spain in 1822, the mission lands and the Native Americans that worked the land also eventually became independent.

Julio Verdugo prospered as a cattle rancher for many years when demand for hides was high. But he also had to defend his land from the cattle ranching of the San Gabriel Mission and later land grants given by California governors during the Mexican era. However, Julio's land disputes during the Spanish and Mexican eras were minor compared to the disputes he would face under the American government.

In 1847, Mexico lost the war against the United States, and in 1850 California became the 31st state to join the Union. Although land ownership had been established and confirmed during the Mexican era, the American government developed a new system to survey land and confirm ownership. Landowners were required to provide proof of ownership before the newly created board of land commissioners. The pioneering attorney for the Pueblo de Los Angeles

and the Verdugo family was Joseph Lancaster Brent, who helped secure the title for Julio and Catalina and was paid for legal services through a large deeded tract that later became the Santa Eulalia Ranch, Tropico, and Atwater. Also during this time Julio sold a portion of the Rancho San Rafael at the southern end near Los Angeles to Samuel Hunter (later becoming Highland Park) to pay for taxes. The California Gold Rush made Julio and other cattle ranchers prosperous as the demand for meat and hides increased. When the Civil War broke out, Joseph Lancaster Brent left Los Angeles to fight for the Confederacy, and Julio lost the attorney who had navigated him though the American legal system.

The end of the gold rush and the decreasing demand for cattle hides changed the California economy forever. Cattle ranching was phasing out. Making things worse for the Verdugos and many other cattle ranchers in Southern California was the severe flooding followed by a long drought from 1861 to 1863. In 1861, Julio and his wife, Maria de Jesus Romero, needed cash to enlarge their adobe home, buy seed, order supplies, and pay taxes. Like others, Julio had to borrow money. There were no banks at this time so often merchants would provide loans at exorbitant rates. In 1861, Julio borrowed $3,445.37 from a Los Angeles merchant named Elias Jacob. The interest rate was an astonishing 3 percent per month, payable quarterly and compounding to over 40 percent per year. Much of Julio's cattle herd died in the drought. As a result, he was unable to make payments, and his principal and interest grew exponentially. Julio was taken to foreclosure court in 1864 with a judgment of $10,795. The matter was contested bitterly, but the court decided against Julio in 1869 for total due of $58,750, or the whole of the Rancho San Rafael and Rancho La Canada.

The purchaser of the debt and the land in foreclosure court was the prominent and wealthy Los Angeles attorney Alfred B. Chapman. Because other portions of the Rancho San Rafael were deeded by Catalina and Julio to Julio's children while still other portions, such as the Brent tract, had been deeded, traded, or sold prior, Chapman and other newcomers to the area demanded more security in terms of their new holdings. To settle the case of ownership, Chapman and these newcomers took the Verdugo family and others to court. By this time, both Julio and Catalina were very old, and Fernando Sepulveda, the husband of Julio's daughter Rafaela, defended the Verdugo family interest. The court case confirmed the title of land and water rights to 28 claimants and 36 defendants. Of the Verdugo family, Rafaela, Teodoro, and Catalina were confirmed the largest portions, and Julio received 200 acres that included his home site near the corner of today's Verdugo Road and Acadia Avenue. A portion of Julio's 200 acres was passed on to Julio's other children. Catalina died during the proceedings in 1871, and in 1876 Julio died at the age of 87. Dora Verdugo, a daughter of Teodoro Verdugo, was one of the last known descendants of the Verdugo family, dying in Glendale in 1984. The actress Elena Verdugo is another known descendent of the Verdugo family.

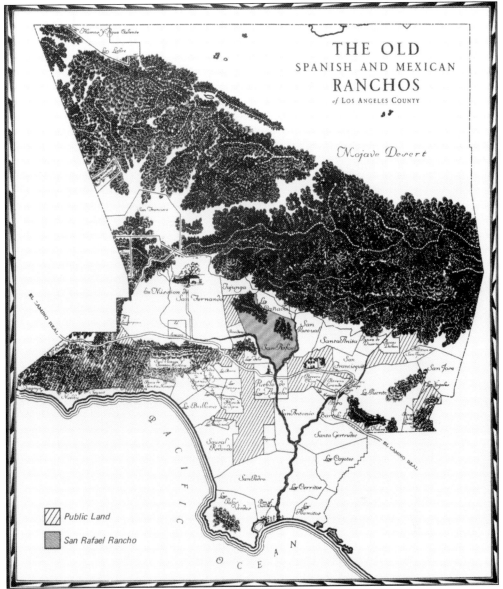

The Old
SPANISH AND MEXICAN
RANCHOS
of Los Angeles County

Public Land

San Rafael Rancho

This Spanish and Mexican rancho map of Los Angeles County, prepared by the Title Insurance and Trust Company, outlines the various Spanish and Mexican ranchos and shows the triangular-shaped Rancho San Rafael in the center just above the Pueblo de Los Angeles to the south and the Rancho La Canada to the north. In 1784, Governor Pedro Fages gave three large and distinct land grants to three Spanish soldiers, which began a long history of over 800 land grants by the Spanish and then Mexican governments of Alta California. Jose Maria Verdugo was among those first three soldiers granted their request. (Map taken from the 1977 City of Glendale Historic Preservation Element of the General Plan.)

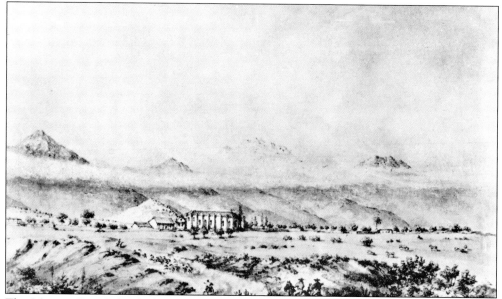

The Mission San Gabriel, shown here in a painting by Edward Vischer c. 1842–1865, was founded in 1771 as the fourth mission of the Gaspar de Portola Spanish expansion north. Jose Maria Verdugo knew of the lands he called *La Zanja* from travels to Monterey, the approximate route of today's Ventura Freeway. (Courtesy of the California Historical Society, University of Southern California Regional History Department.)

During the rancho era, depicted here in a drawing by Ogilby, Julio prospered as the *padron* on the vast Rancho San Rafael when the hides of California cattle were in high demand and were shipped to New York and Boston. His sister Catalina was blinded from smallpox at an unknown age and was cared for by Julio's 12 sons and 2 daughters. (Courtesy of the Seaver Center for Western History Research, Los Angeles County Museum of National History.)

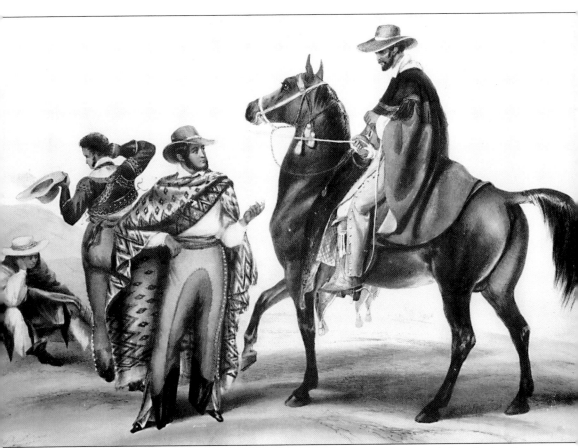

This *c.* 1840 Carlos Nebel lithograph of a California rancho scene is intended to depict the dress and stature of Julio Verdugo as the judge, or *padron*, of the Rancho San Rafael. Julio was known to hold many rodeos and fiestas on his rancho, which was worked by vaqueros. Native Americans served as vaqueros and farmed the land. (Courtesy of the Seaver Center for Western History Research, Los Angeles County Museum of National History.)

When a portion of Julio Verdugo's Rancho San Rafael on the south and western end was granted to Vicente de la Osa, Julio politely disputed this action to Governor Micheltorena in this letter, claiming that the land being given to Vicente de la Osa was a portion of his Rancho San Rafael given to him by his father. In the end, however, the Mexican governor confirmed the land to Vicente de la Osa, which became Rancho Providencia, a part of today's Burbank. (Courtesy of the Special Collections Room, Glendale Public Library, from the Elena Verdugo collection.)

In 1843, a land grant was given to a Mexican soldier named Ygnacio Coronel, father of Antonio F. Coronel, who is shown here with his wife, Mariana, c. 1885. Coronel named the territory he pursued La Canada Atras de Verdugo. Julio disputed this grant, claiming it was a confirmed part of his Rancho San Rafael. The governor, however, countered that Julio was not using this portion and the grant proceeded, establishing the Rancho La Canada. Ygnacio Coronel later conveyed his Rancho La Canada to Jonathan R. Scott, another early California attorney. Julio, wanting this portion of his Rancho San Rafael back as it contained valuable wooded low land with a good supply of water, worked out a trade with Scott in 1858. In exchange for the Rancho La Canada, Julio gave a western parcel of land to Scott that the attorney later sold to a dentist named David Burbank who joined with the Providencia Land, Water, and Development Company to create the town site of Burbank and subdivided today's northwest Glendale in 1887. (Courtesy of the History Collections, Los Angeles County Museum of National History.)

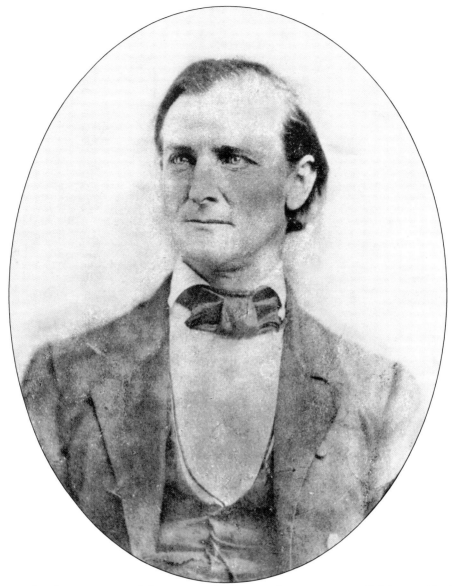

Because the American way of determining land ownership was new to Californios like Julio and Catalina Verdugo, a few very knowledgeable attorneys came to facilitate the process. One of those men was Joseph Lancaster Brent, shown here in 1855, who came from Baltimore, Maryland, in 1851, bringing with him Southern California's first law library. Brent learned Spanish and represented Julio and Catalina before the board of land commissioners. After Julio and Catalina won confirmation to ownership of the Rancho San Rafael, they compensated Joseph Lancaster Brent for his services with a payment of land rather than money since Julio and Catalina dealt in a barter economy. This large parcel was sold for cash, exchanged hands, and was then sold to W.C.B. Richardson in 1868, becoming known as the Santa Eulalia Ranch. (Courtesy of the Special Collections Room, Glendale Public Library.)

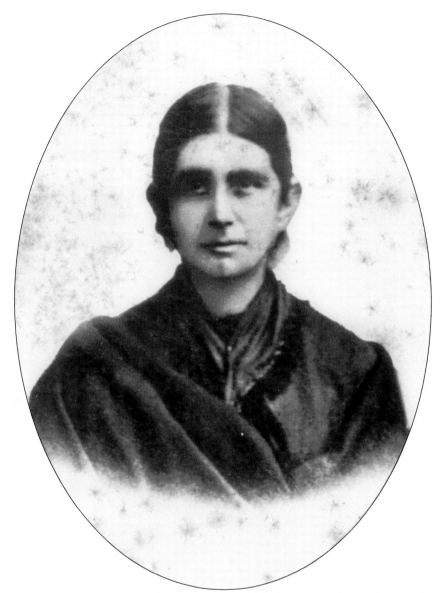

Senora Rafaela Verdugo de Sepulveda was one of Julio's two daughters. Born in 1819, she received a large parcel of the Rancho San Rafael reportedly from her aunt Catalina. In 1844 she married widowed Fernando Sepulveda who was from the large Sepulveda family granted land in other parts of Los Angeles and Orange County. Since he married into the Verdugo family, he did not own a part of the Sepulveda family ranchos. Rafaela later deeded land to Maria Sepulveda de Sanchez, who was Fernando's daughter from his first marriage and the wife of Tomas Sanchez, sheriff of Los Angeles County. Fernando defended Rafaela and the Verdugo family's interest in the 1871 court case to determine land titles. Fernando died at his home in 1875 at the age of 61. Rafaela died in 1904. (Courtesy of the Seaver Center for Western History Research, Los Angeles County Museum of National History.)

Maria Sepulveda de Sanchez was born around 1837 and in 1867 married Tomas Sanchez. Together they built the Sanchez adobe still in existence today. After Tomas died in 1882, Maria sold the adobe and her land to Andrew Glassell in 1883 and moved out of the area with her children. The Sanchez adobe had many owners before the City of Glendale purchased the property in 1932. (Courtesy of the Special Collections Room, Glendale Public Library.)

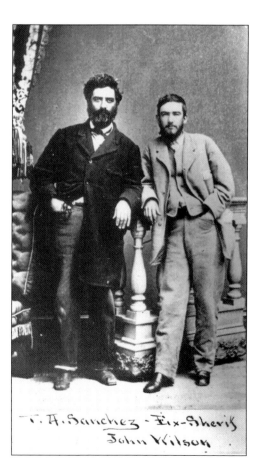

Tomas Sanchez (left), shown here with John Wilson sometime in the 1870s, was known best as the "brave" sheriff of Los Angeles County from 1859 to 1867. He was the grandson of Vicente Sanchez, the grantee of the Rancho Cienega during the Mexican era. (Courtesy of the Seaver Center for Western History Research, Los Angeles County Museum of National History.)

18

Capt. Cameron Erskine Thom came to California from Virginia during the gold rush in 1849 and later studied law and started his career taking testimony in land claims before the board of land commissioners. Eventually, he was elected both city and county attorney and served in the state senate from 1859 to 1860. Although he moved back to Virginia to become an officer for the Confederacy, he returned to California after the Civil War and purchased land from Catalina Verdugo. Thom served as mayor of Los Angeles from 1882 to 1884. (Courtesy of the Special Collections Room, Glendale Public Library.)

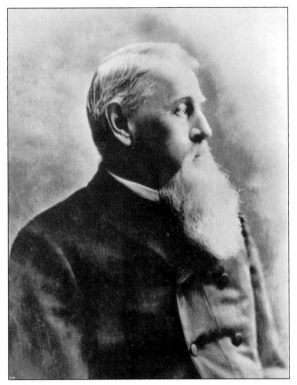

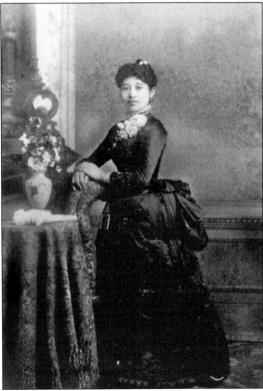

This unknown member of the Verdugo family, pictured c. 1880, is most likely a daughter of either Rafaela or Teodoro Verdugo, who received large tracts of land in today's northern Glendale reportedly from their aunt Catalina. (Courtesy of the Special Collections Room, Glendale Public Library.)

Alfred Beck Chapman came to California in 1854 and practiced law with Andrew Glassell in Los Angeles for 20 years. He studied law with Jonathan Scott and later married Scott's daughter. He was district attorney in 1863 and 1868 and was one of the founders of the town of Orange in the 1870s. He also attempted to establish the settlement of Riverdale from his holding in the Rancho San Rafael. (Courtesy of the California Historical Society, University of Southern California Regional History Department.)

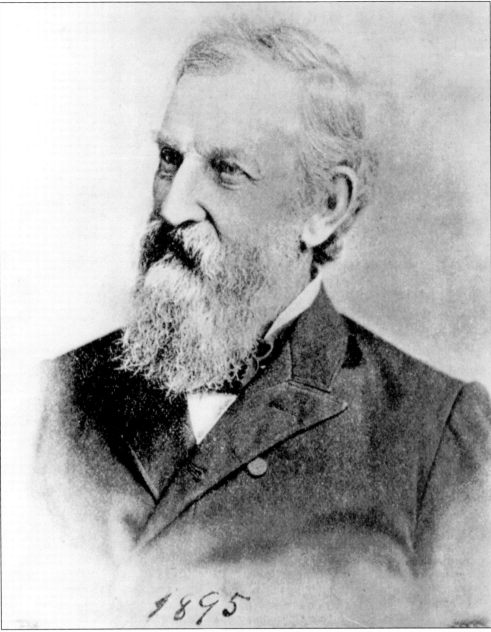

1895

In 1870, the court decreed that the ranchos should be partitioned, and appointed Judge Benjamin S. Eaton (shown here in 1895), J.H. Landers, and A.W. Hutton as referees. Their findings ordered that the ranchos be divided in 31 parts among 28 different persons. Eaton came to California from New England in 1850. In 1853 he served as district attorney and in 1857 as county assessor. He was also one of the founders of the Pasadena Colony. (Courtesy of the Special Collections Room, Glendale Public Library.)

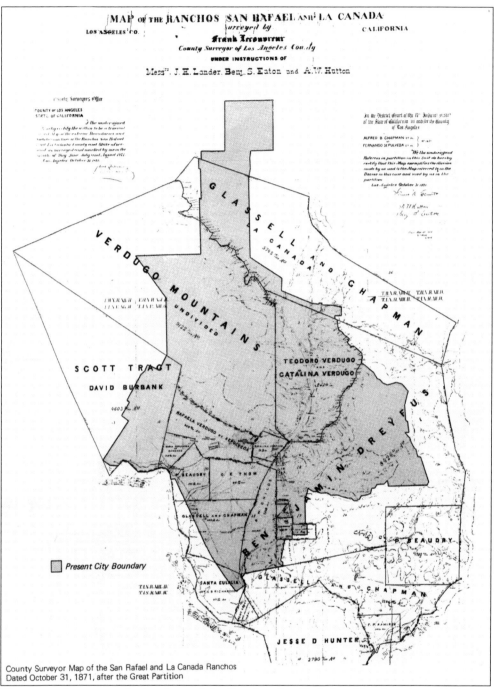

County Surveyor Map of the San Rafael and La Canada Ranchos
Dated October 31, 1871, after the Great Partition

This image documents the break up of the Ranchos San Rafael and La Canada in 1871. It is also referred to as "The Great Partition" since the court case was instrumental in demonstrating the need to determining title to land ownership. Ironically for Julio and Catalina, a patent to their 36,000-acre Rancho San Rafael was confirmed to them in 1882 after they both died. (Map taken from the 1977 City of Glendale Historic Preservation Element of the General Plan.)

Two

SETTLEMENT
OF THE VALLEYS
1872–1904

With the breakup of the Rancho San Rafael, unlimited opportunities for settlements presented themselves. Glassell and Chapman, who were also working and investing in the Orange County area, intended to create subdivisions and towns. The earliest settlements carved out of the former Rancho San Rafael were Highland Park and Garvanza, which were subdivided in the 1870s. In 1876 Chapman subdivided the area along the Los Angeles River, later known as West Glendale, into smaller parcels for an early town site development he named Riverdale. There was hope that the Southern Pacific would build a depot in the area as they expanded to the West Coast in 1872 and that the town site would flourish, but Chapman's Riverdale didn't happen as planned. Not only was there another California town named Riverdale, but the final setback was the Southern Pacific locating its depot farther south on land donated by W.C.B. Richardson from his Santa Eulalia Ranch. The Southern Pacific called the depot Tropico. This meant that Richardson's Santa Eulalia Ranch would be ready to expand. Settlers poured into the valley, mostly from Ohio, Indiana, Iowa, Illinois, and also from the East Coast, when the Southern Pacific and the Union Pacific engaged in rate wars offering fares for $1.

Andrew Glassell and Alfred Chapman sold off the former Rancho La Canada to Dr. Jacob Lanterman and Col. Adolphous Williams in 1875. In the La Canada Valley, development challenges included the lack of train transportation to the area and a limited water supply. Early home seekers arrived beginning in 1871 to settle on the slopes north of the Rancho La Canada. The two men from Michigan, who suffered from lung diseases and had originally come to create a health resort of the Rancho La Canada, split the land between them after creating 46 lots, 100 acres each. Lanterman took the eastern portion and Williams (who sold to Dr. Benjamin Briggs) took the western portion. Briggs named his western portion La Crescenta because the shape of the valley and mountains made a crescent. Briggs subdivided the Crescenta Valley in 1882 into smaller uniform parcels. Lanterman kept the name La Canada from the former

Rancho La Canada for his eastern portion of the valley.

By 1883, several small settlements could be found throughout the former Rancho La Canada and Rancho San Rafael. Early settlement names included La Canada, Verdugo, Riverdale, and Sepulveda. Fruit orchards were planted throughout, although other areas remained as sagebrush. In 1883 the new settlers began meeting to organize for improvements and to give a name to their area. The real estate boom that intensified by 1886 made these areas ripe for development, and in 1887 W.C.B. Richardson recorded with the county a town site around the Tropico depot, always referred to as Tropico.

Other settlers near today's Broadway and Glendale Avenue united and decided they also needed a name. It was reported that a women from Chicago suggested the name "Glendale" after painting the landscape of the valley against the mountains. The name satisfied the group and was adopted. The group included a couple of men from the Midwest named Benjamin F. Patterson and Ellis T. Byram who arrived in 1883 as permanent settlers. Capt. Cameron Erskine Thom was an early landowner in the central portion of the valley and although he developed early citrus orchards there, he never lived in the Rancho San Rafael but was nonetheless always a proponent for township status. Another early settler was Henry J. Crow who owned and lived on his ranch along today's Lomita Avenue. These men, Patterson, Crow, Byram, and Thom, pulled their holdings together to create a town site which they recoded in 1887 as the Town of Glendale. Byram was the agent for the town lots; however, most of these lots were never sold because the boom of the 1880s turned into the depression of the 1890s. Very little happened in Glendale's valley during this time, with the most significant change being that Edgar D. Goode moved into Glendale with serious plans for its future. In addition to reactivating the Glendale Improvement Association, Goode helped in the fundraising and land acquisition for the valley's first high school. In 1901, a site was found, and in 1902 the Glendale Union High School opened, servicing the students from the Glendale, West Glendale, Tropico, La Crescenta, Eagle Rock, Ivanhoe, and Burbank school districts. The site was at the southeast corner of today's Broadway and Brand Boulevard.

With the high school accomplished, Goode pursued the next important project: to bring commuter rail transportation to Glendale. In 1903, a capitalist by the name of Leslie C. Brand took a liking to Glendale's valley and, like Goode, saw that the area had potential for future development. He believed in the area so much that he built his grand home on a large parcel of land at the foothills of the mountains. Brand was famous for his enterprising work in the title business in Los Angeles and generated a lot of wealth. He also had development pursuits in Pomona and the San Fernando Valley but believed the setting of north Glendale's valley, foothills, mountains, and air offered something special. In 1903, he became the president of the Los Angeles Inter-Urban Electric Railway Company (soon after called the Pacific Electric) established by Henry Huntington who created cities and towns all over Southern California with electric streetcars. E.D. Goode worked with Brand to bring the Pacific Electric to Glendale. Leslie Brand, with the cooperation of the Tropico and Glendale Improvement Associations, secured the land for the train right-of-way line from the base of the foothills to near the Tropico Depot with a station stop across from the new high school. In April 1904, the Pacific Electric Line opened, ensuring that Tropico and Glendale would flourish.

In the first *Directory of Los Angeles City and County* published in 1872, Prudent Beaudry, an early subdivider of downtown Los Angeles and Los Angeles mayor from 1874 to 1876, included this real estate advertisement for land in the Rancho San Rafael. Beaudry owned 1,702 acres in the Rancho San Rafael as confirmed in 1871.

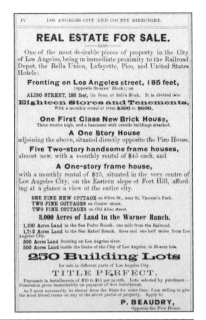

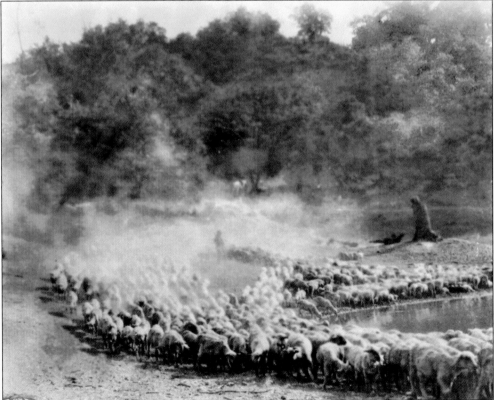

This picture, taken in the early 1880s, shows one of the last sheep herds found on the Rancho San Rafael. When the cattle economy diminished, sheep herding continued to remain viable until fruit orchards and land speculation replaced it. (Courtesy of the California Historical Society, University of Southern California Regional History Department.)

Theodore Pickens, a Union veteran of the Civil War and native of Kentucky, was the first settler in the Crescenta valley. In 1871 he homesteaded on what is now Briggs Terrace, just above Rancho La Canada, and claimed the water rights to Pickens Canyon, the main water source for the Crescenta-Canada Valley. Pickens supported himself by logging the thick stands of big cone douglas fir trees that forested the canyon in those days to feed the hungry brick kilns of growing Los Angeles, and sold water to ranchers in the valley below. He sold his homestead to Benjamin Briggs in 1881. (Courtesy of the Special Collections Room, Glendale Public Library.)

Los Angeles County Schools formed the Sepulveda School District in 1879, including all of the former Rancho San Rafael boundaries, and by 1882 the district had 130 children. Many of the children attending the first schoolhouse along Verdugo Road at the base of the woodland area were the children of the native Californios, namely the Verdugos, Sepulvedas, and Sanchezes. But soon the children of the settlers of 1883 outnumbered the Spanish surname student population, as can be seen by this Sepulveda School District attendance record. (Courtesy of the Special Collections Room, Glendale Public Library.)

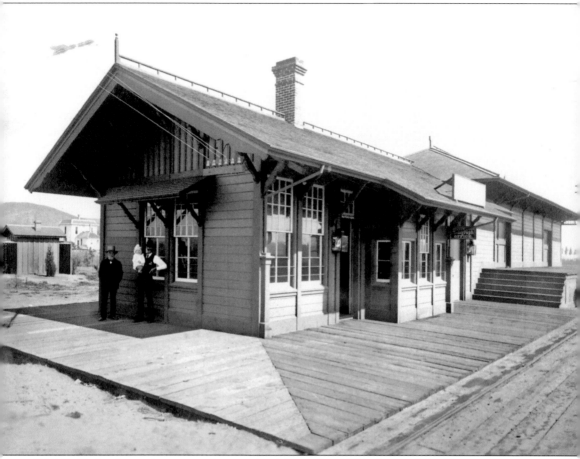

W.C.B. Richardson, shown standing to the left in this 1883 photo of the Tropico Depot, donated 16 acres of his Santa Eulalia Ranch to construct the first depot stop of the Southern Pacific Railroad north of Los Angeles in 1877. Ten years later, he recorded a town site around the depot known as the town of Tropico, a name loosely used for the settlement since 1883. (Courtesy of the Special Collections Room, Glendale Public Library.)

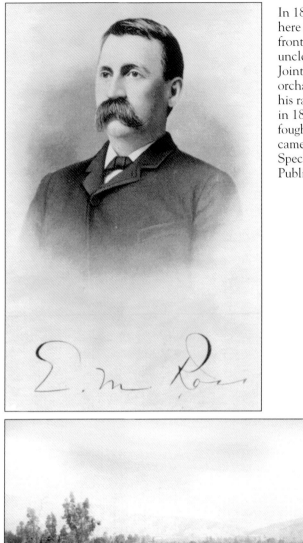

In 1872, Erskine Mayo Ross, shown here c. 1880, bought 1,100 acres of land fronting north Verdugo Road from his uncle Capt. Cameron Erskine Thom. Jointly they planted the first orange orchards in the valley. Ross, who lived on his ranch, became a superior court judge in 1879 and 1886. Like his uncle, he fought in the Civil War and afterwards came to California. (Courtesy of the Special Collections Room, Glendale Public Library.)

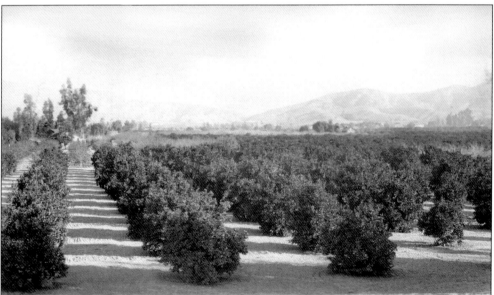

By 1889, the time this photo was taken, land in the former Rancho San Rafael went from sagebrush to fruit orchards, producing variable profits over the years. Much of the land was held for speculation. Nearby Los Angeles and Pasadena were established cities by this time. (Courtesy of the Special Collections Room, Glendale Public Library.)

John Calvin Sherer first came to California in 1875 from the East Coast writing about his travels. He was instrumental in the early Glendale Improvement Association and developed fruit cooperatives, churches, and school buildings and was Glendale's first treasurer when the town incorporated in 1906. Always taking an active part in Glendale's history, in 1922 he wrote the 295-page *History of Glendale and Vicinity*. (Courtesy of the Special Collections Room, Glendale Public Library.)

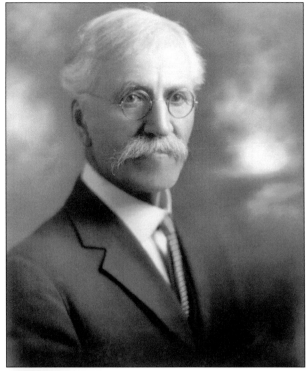

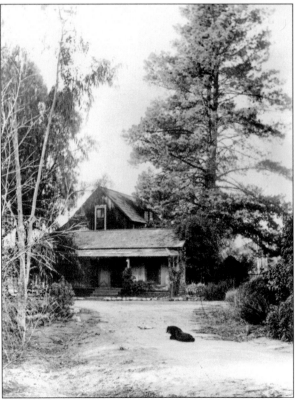

In 1880, John Calvin Sherer purchased 17 acres along south Verdugo Road near the former home site of Julio Verdugo and moved into a two-room cabin in 1883, which he enlarged into a substantial farmhouse in 1918. This photo shows his Somerset Farm in 1902. (Courtesy of the Special Collections Room, Glendale Public Library.)

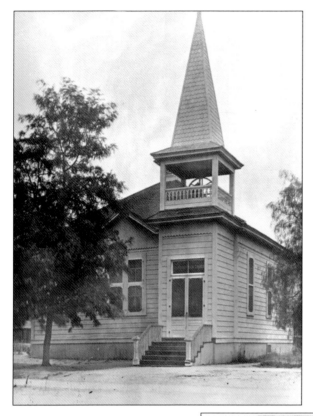

The Presbyterian Church of Riverdale was organized in 1884. Its first building, constructed in 1885, was only 36-foot square in size and located on Crow Avenue (today's Glendale Avenue) and Tenth (today's Windsor Road), a point for the boundary line between Tropico and Glendale. In 1888, the church moved to Broadway and Cedar Street on land donated by Patterson and Byram. (Courtesy of the Special Collections Room, Glendale Public Library.)

The Crescenta Valley was widely known for its dry air, once thought to be perfect for the treatment of lung diseases such as asthma and tuberculosis. Patients flocked there starting in 1881, when Dr. Benjamin Briggs established the first sanitarium, the Briggs Home (shown here c. 1882), for the treatment of lung diseases. The hotels and sanitariums of La Crescenta flourished into the 1930s. (Courtesy of the Seaver Center for Western History Research, Los Angeles County Museum of National History.)

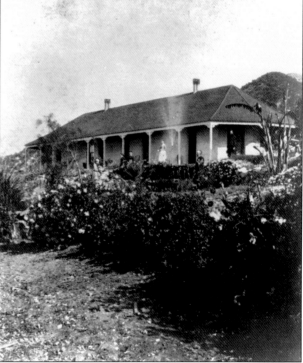

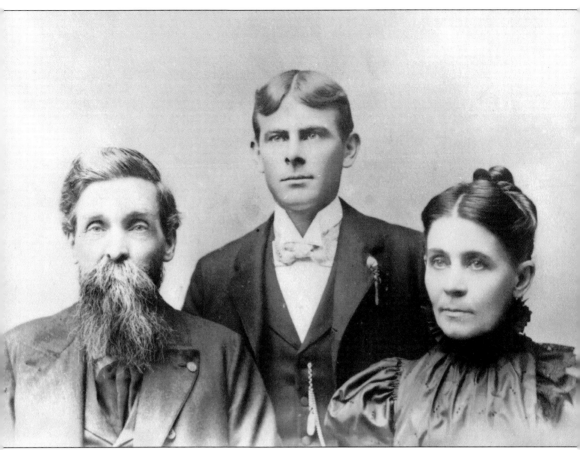

Benjamin F. Patterson, his wife, Mary E., and son Oren Elldon are shown in this c. 1885 portrait. Patterson moved from the Midwest to Glendale in 1882 and settled in the area around today's Belmont Street and Wilson Avenue, where he bought 52 acres of land. In 1883, he invested in 13 parcels of land totaling 123.5 acres. Patterson and Byram, using land from the Thom, Ross, and Crow ranches, pulled together to create a town called Glendale. Because Glendale did not have the advantage of the Southern Pacific route like Tropico, the men encouraged the extension of the Los Angeles and Salt Lake Railroad line up Crow Avenue, called the Los Angeles and Glendale Railroad Company, founded when the town of Glendale was established. The three Patterson daughters are pictured separately. (Courtesy of the Special Collections Room, Glendale Public Library.)

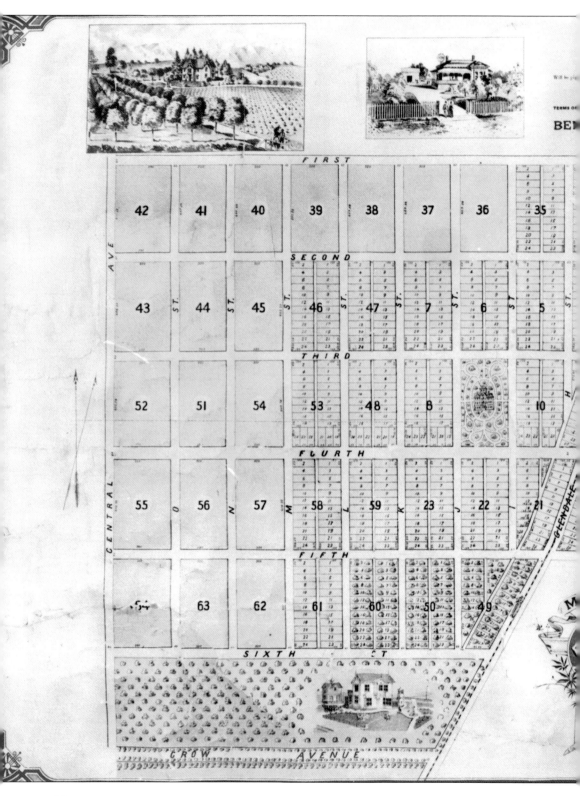

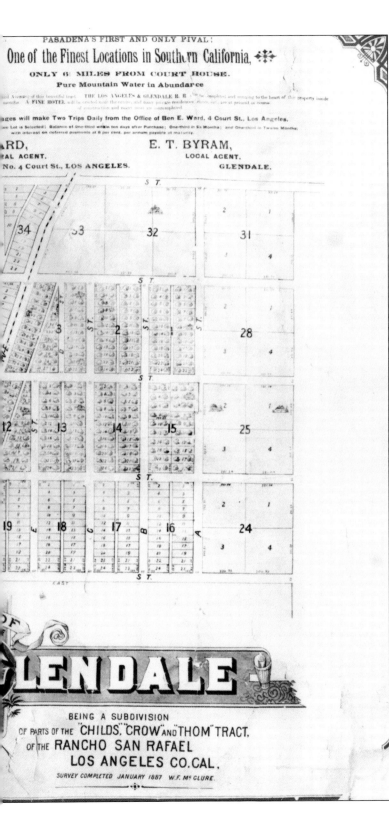

BEING A SUBDIVISION
OF PARTS OF THE "CHILDS" "CROW" AND "THOM" TRACT.
OF THE RANCHO SAN RAFAEL
LOS ANGELES CO. CAL.
SURVEY COMPLETED JANUARY 1887. W.F. McCLURE.

To claim the small settlement of Glendale, this map of the Town of Glendale, California, was recorded in 1887. Glendale's distinction was being "Pasadena's First and Only Rival." Advantages included being six miles from central Los Angeles and having an abundance of pure mountain water. The developers made good on their claims by providing water, a hotel, and rail transportation along Glendale Avenue. Lots could be purchased with $50 down. Streets were numbered First Street (Lexington) to Sixth Street (Colorado) from north to south, and "A" Street (Adams) to "O" Street (Orange) from east to west. Byram's and Crow's houses are shown on the map, which also shows seven homes on small lots and four larger ranch homes. (Courtesy of the Special Collections Room, Glendale Public Library.)

33

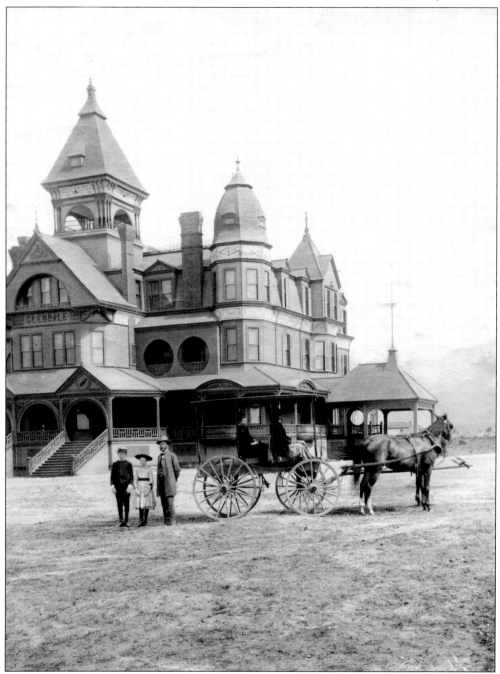

The Glendale Hotel, a grand Victorian hotel shown here in 1888, became the symbol of Glendale's ambition to attract Easterners and Midwesterners to invest in the new town and show the strength of the community. Crow, Thom, and Ross all invested heavily in the construction of the hotel, which was a landmark structure that could be seen from miles away. Unfortunately, the 75-room hotel was only open for a year because the boom of the 1880s ended shortly after it opened and left Glendale and other Southern California towns without many visitors. (Courtesy of the Special Collections Room, Glendale Public Library.)

Edgar D. Goode was known as the father of Glendale, a man who believed in the town's future and was instrumental in reactivating the Glendale Improvement Association. During the boom period of the 1880s, improvement associations were formed to advance town developments, including the major objectives of train transportation and publicity. Other focuses were on paving streets, building schools, and establishing churches. (Courtesy of the Special Collections Room, Glendale Public Library.)

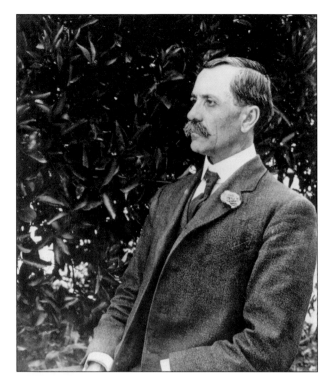

Mrs. Alletia Goode and her husband, E.D. Goode, came to settle in Glendale in 1894. E.D. In 1882, Goode married Miss Alletia Suttle of his native Taylorville, Indiana. Together they had three boys and two girls. Daughter Fay Goode was one of Glendale Union High School's first graduating class of four. Mr. and Mrs. Goode left Glendale in 1913, but their house still stands today. (Courtesy of the Special Collections Room, Glendale Public Library.)

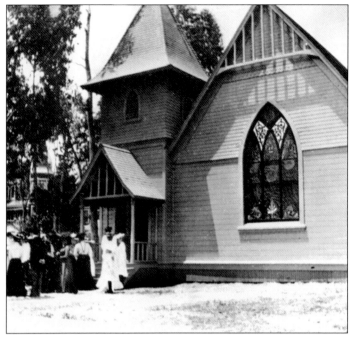

Considered the pioneer church of Glendale's valley, the Saint Mark's Episcopal Church, shown here in 1893, was incorporated in 1884 as the Riverdale M.E. Church first located at today's Glendale Avenue and Windsor Road. The church later moved to the northeast corner of today's Broadway and Isabel Street. (Courtesy of the Special Collections Room, Glendale Public Library.)

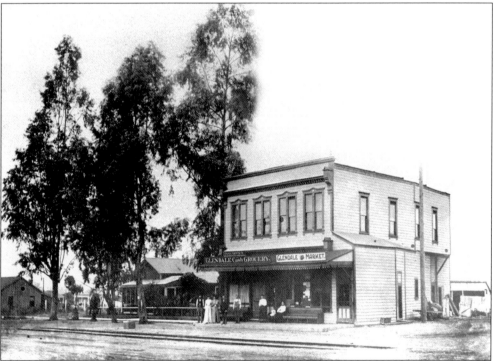

Built in the 1880s, the Glendale Cash Grocery and Glendale Market stood at the southwest corner of Glendale Avenue and today's Wilson Avenue and marked the center of town. Other similar stores in the valley included the Verdugo Cash Store on the northwest corner of Verdugo Road and today's Colorado Street and the Tropico Cash Store on San Fernando Road. This photo was taken in 1895. (Courtesy of the Special Collections Room, Glendale Public Library.)

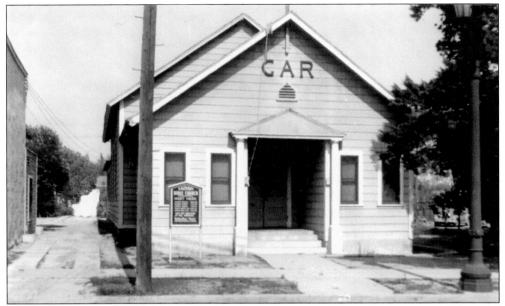

This photo taken in 1941 shows one of the first clubhouses in the valley. The building was constructed by the Independent Order of the Good Templers, an early fraternal club of the valley formed in 1891. The building soon after became the meeting hall of the local chapter of the Grand Army of the Republic, a Civil War veterans' organization. (Courtesy of the Special Collections Room, Glendale Public Library.)

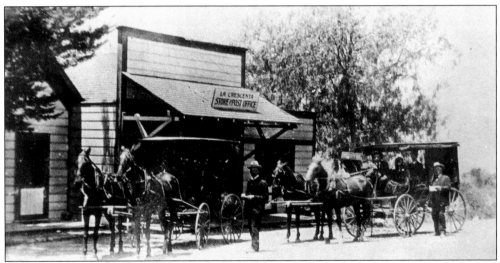

Located at the dusty intersection of today's Foothill Boulevard and La Crescenta Avenue, the La Crescenta Store and Post Office, shown here in 1895, anchored the original town center. These two stagecoaches made regular runs from Pasadena, bringing sightseers to view the local Gould Castle and Strong Castle as well as guests to stay at the resort hotels of the valley, including the Fairmont Hotel and the Silver Tree Inn. (Courtesy of the Special Collections Room, Glendale Public Library.)

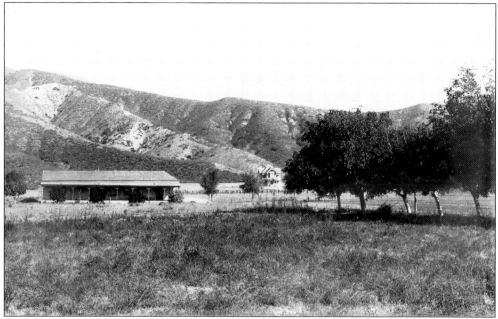

In 1900, J.D. Bliss purchased 500 acres from the Rev. George Baugh, a retired Church of England clergyman who purchased land from Rafaela Verdugo in the 1880s. The land that made up the Bliss Ranch included the Sepulveda adobe home shown in the foreground. (Courtesy of the Special Collections Room, Glendale Public Library.)

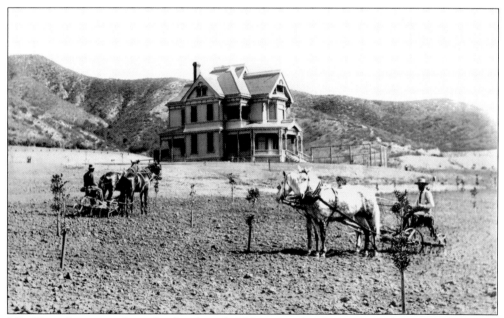

J.D. Bliss, shown on the right, lived in this Victorian farmhouse for only a very short time as he sold the land to the Huntington Land and Investment Company for the right-of-way to complete the Los Angeles Inter-Urban Electric Railway extension planned for Glendale. (Courtesy of the Special Collections Room, Glendale Public Library.)

Teodoro Verdugo, son of Julio Verdugo, laid out Verdugo Park in 1887. The precious year-round water supply of the Verdugo Canyon caused constant battles over water supply from the days of the 1871 partition to 1912 when the City of Glendale annexed the territory. Teodoro lived in the last adobe of the Verdugo family currently owned by the City of Glendale. This photo of the Verdugo Park stream was taken c. 1900. (Courtesy of the Special Collections Room, Glendale Public Library.)

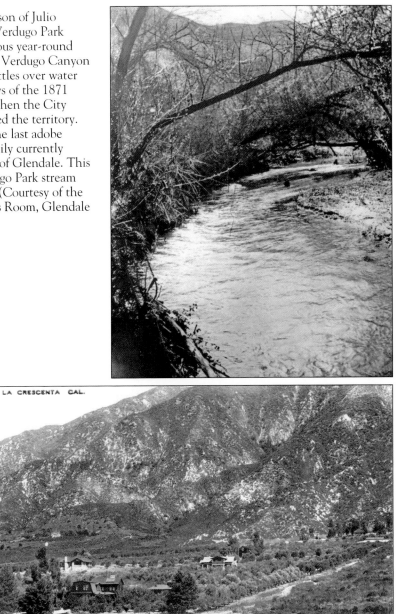

The Fairmount Hotel, the darker structure in the foreground, was one of the resort hotels in the La Crescenta area. Built in 1900 by Miss Gertrude Bremen, it served as a hotel for 23 years. The orchards around the hotel are olive trees, first planted by Benjamin Briggs in the 1800s. The wagon track in the foreground is now Briggs Avenue, and the same olive trees still line that road today. (Courtesy of the Special Collections Room, Glendale Public Library.)

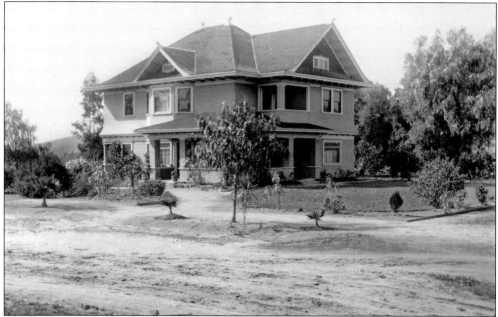

This late 19th-century farmhouse was located on the southeast corner of unpaved Columbus Drive and Riverdale Drive and was typical of the scattered homes that dotted Glendale's valley before the turn of the century. (Courtesy of the Special Collections Room, Glendale Public Library.)

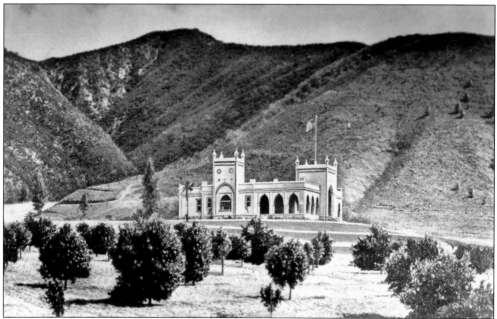

This 1903 photo shows Leslie C. Brand's home, which was named *El Miradero*, Spanish for a home overlooking a wide view. Capitalist L.C. Brand built this home north of Glendale believing, like E.D. Goode, in the future of the town. The home was designed by Brand's brother-in-law in a style influenced by the East Indian pavilion display at the 1893 Chicago World's Fair. (Courtesy of the Special Collections Room, Glendale Public Library.)

Three

GLENDALE COMMUNITIES EMERGE
1905–1918

With the Pacific Electric now servicing Glendale and Tropico, owners of farms and ranches rushed to subdivide their land into residential parcels 50 feet wide by 150 long on average. These subdivisions were scattered and followed no particular pattern, although all of them clustered around the new Pacific Electric line. Communities emerged as streets were paved and schools and churches established. The Pacific Electric made Glendale and Tropico well known communities around Southern California. While both towns flourished, Glendale received a jumpstart when the town's residents decided to form a city.

With a large number of subdivisions being drawn up and recorded in 1905, a city seemed to be the best option for bringing even greater improvements to the area, so the Glendale Improvement Association spearheaded the incorporation effort for Glendale. The vote was controversial but cityhood won on February 7, 1906. Glendale boosters immediately attempted to incorporate a very large territory, although the largest area they were able to get was 1,486 acres from Central Avenue on the west to Windsor Road on the south to Adams Street on the east and Lexington Drive on the north. Until 1918 these streets were numbered from First to Tenth and lettered from "A" (later changed to "Adams") to "O" (later changed to "Orange"). The Glendale and Tropico Improvement Associations named the roadway that aligned itself with the Pacific Electric "Brand Boulevard," after Mr. Leslie C. Brand.

Soon after the Pacific Electric opened, it extended its Glendale route terminus from Brand Boulevard and Broadway farther north to serve foothill land ripe for the next stage of development. L.C. Brand and the Pacific Electric worked together to create this extension and, knowing they would need a destination for the terminus, created a tourist spot called Casa Verdugo with a Spanish-style restaurant and garden to attract the Midwesterners seeking warm weather and healthful conditions. A community known as Casa Verdugo formed around the attraction, extending from Central Avenue on the west to the Thom and Ross ranches on the

east, and from the foothills on the north to the Verdugo wash on the south. Other areas near Casa Verdugo were loosely known as North Glendale.

Another community known as West Glendale was emerging at this time, subdivided into residential lots with some commercial areas along San Fernando Road. Tropico was not interested in joining Glendale in the incorporation effort but continued as a separate community until it decided to incorporate as the City of Tropico in 1911—primarily to protect itself from pressure both from Glendale and Los Angeles to annex.

Incorporation plans began in 1902 and received both support and opposition from valley residents. The Glendale Improvement Association worked at a boundary that would at least include the Glendale School District, and did so by attempting to expand the boundary into the settlement known as Verdugo and as far west as the settlement of West Glendale, but didn't reach that far. In 1906, Glendale became the 16th city in Los Angeles County to incorporate. Nearby Pasadena had incorporated in 1886 and Long Beach in 1888. One of the first actions of the new city government was to pass a law banning pool halls.

Meanwhile, other communities were forming. In the Crescenta Valley, a small settlement that was taking shape became known as La Crescenta with Michigan Avenue and La Cresenta Avenue as the planned town center. In 1913, the town of Montrose began as more than just a residential subdivision, with curving streets, commercial and residential development, and new rail transportation. The wooded area known today generally as Verdugo Woodland was not developed until the 1910s, since some of the land was still in Verdugo ownership and struggles over the water sources from the canyon continued until city annexation occurred in 1912.

In 1908, the *Glendale News* reported an estimated 150 homes for the West Glendale area, 230 for the central area of Glendale, and 375 for the area east of Glendale Avenue for an estimated city population of 3,500. West Glendale was annexed in 1911 without much struggle, and the entire city of Tropico was annexed in 1918 after many struggles back and forth. In 1911, Glendale set off to pave Brand Boulevard and Broadway, and in 1912 built its first true city hall. World War I slowed development somewhat, especially in Montrose, but after the war conditions were set for continued expansion and development, and by 1918 Glendale had grown in size to 6,957 acres.

In 1909, Glendale was the site of one of the first motion picture companies on the West Coast. Glendale was a favorite location for outdoor filming since it offered a variety of settings especially for westerns. The Kalem Studio established its West Coast operation at the northwest corner of Broadway and Orange Street but growth caused the company to move to a much larger site on Verdugo Road. The studio later became the Astra Film Corporation producing numerous silent films from 1915 to 1919.

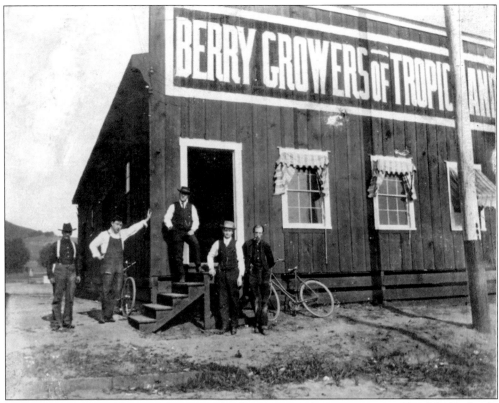

By 1904, Tropico had become the center for shipping strawberries grown in Glendale, Burbank, and Tropico after strawberry growers organized into a structured association. Wilmont Parcher served as the association's first president and would later become the City of Glendale's first mayor. (Courtesy of the Special Collections Room, Glendale Public Library.)

At the height of the strawberry market, the "Tropico Beauty," identified by specially illustrated crate labels, was the pride of the growers. By 1908, strawberry production was phasing out due to overproduction. (Courtesy of the Special Collections Room, Glendale Public Library.)

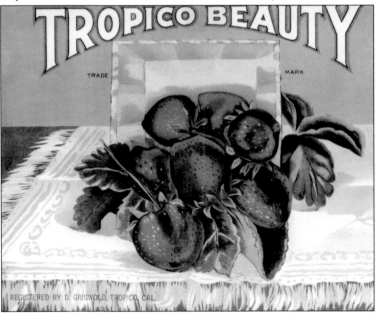

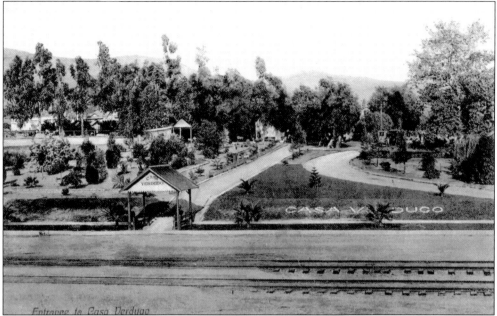

When the Pacific Electric extended their vast streetcar system to the undeveloped area north of Glendale, they created a tourist destination at the terminus that introduced the whole valley to outsiders. The entrance is shown in this photograph. The developing community surrounding the Casa Verdugo gardens and restaurant would simply become known as Casa Verdugo. (Courtesy of the Special Collections Room, Glendale Public Library.)

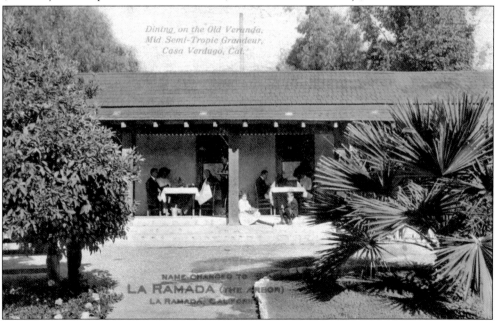

Although Rafaela and Fernando Sepulveda were the former owners of the adobe home that became Casa Verdugo, the restaurant was mistakenly named for the Verdugos. Disputes between the Pacific Electric owners and the operators of the restaurant caused a split and a name change to La Ramada. (Courtesy of the Special Collections Room, Glendale Public Library.)

In 1905, the Pacific Electric system opened up Glendale for widespread subdivision activity. This included the former Crow Ranch, where in the 1870s H.J. Crow lined Lomita Avenue with large eucalyptus trees. This area became known as the Lomita Tract and a settlement for early actors and artists. This is a view of the Lomita Avenue stop looking west. (Courtesy of the Special Collections Room, Glendale Public Library.)

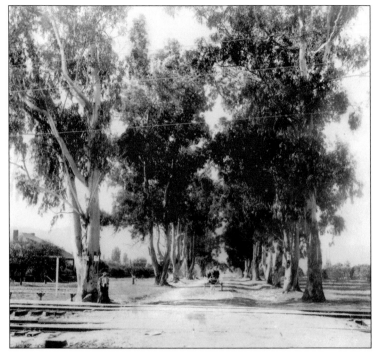

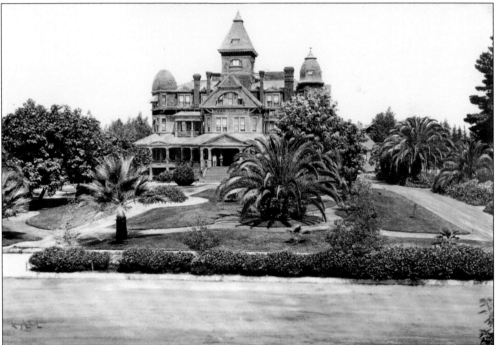

In 1905, Leslie C. Brand purchased the old Glendale Hotel and sold it to the Seventh Day Adventists who converted the once grand hotel into a successful sanitarium. The Glendale Sanitarium, located at Fourth Street (Broadway) and "I" (Isabelle Street), provided hospital services in the hotel until they outgrew the facility in 1924. Soon after, Glendale's landmark was demolished. (Courtesy of the Special Collections Room, Glendale Public Library.)

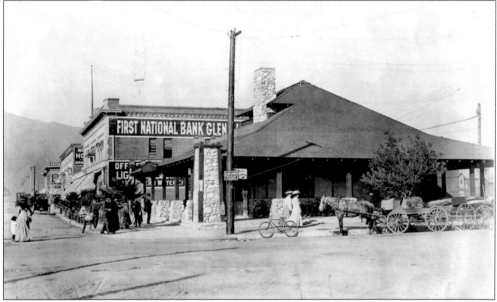

In 1906, Pacific Electric constructed this depot for Glendale at the northeast corner of Brand Boulevard and Broadway, which would forever mark the center of town. The Craftsman-style depot was located just south of the first brick building in Glendale built by L.C. Brand in 1905 as the First National Bank of Glendale. (Courtesy of the Special Collections Room, Glendale Public Library.)

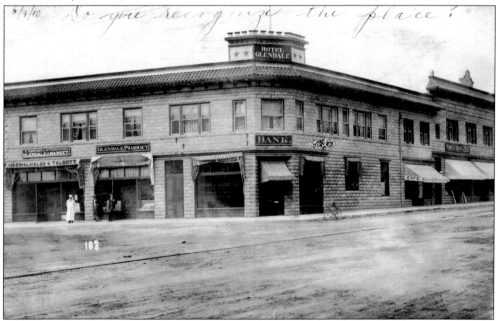

The first bank to come to Glendale was constructed in 1905 under the efforts of the original town settlers. Located at the northwest corner of Third Street (Wilson Avenue) and Glendale Avenue, the bank's image was used in advertising Glendale as the ideal location and environment for the homebuilder. This photo was taken in 1908. (Courtesy of the Special Collections Room, Glendale Public Library.)

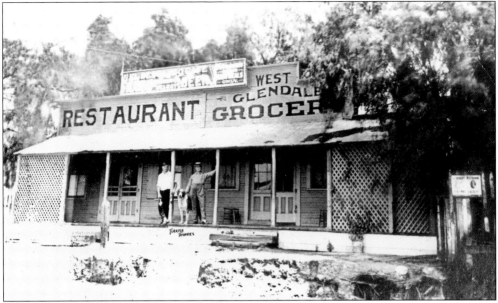

The West Glendale Road House, shown here in 1906, served as a highway stop along San Fernando Road at Doran Street providing groceries, a restaurant, and beer at the El Descanso Café. Because West Glendale was unincorporated county territory, liquor licenses were easier to obtain than in the newly incorporated "dry" city of Glendale. (Courtesy of the Special Collections Room, Glendale Public Library.)

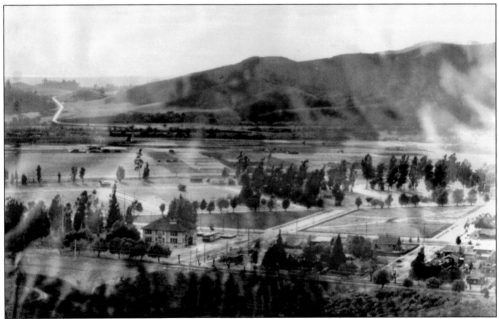

This 1906 photograph of Tropico School (site of today's Cerritos Elementary) was taken looking west through sparsely populated Tropico with the newly constructed school in the foreground. This was the second school on the site of the original Riverdale schoolhouse and represented the center of early valley settlement. (Courtesy of the Special Collections Room, Glendale Public Library.)

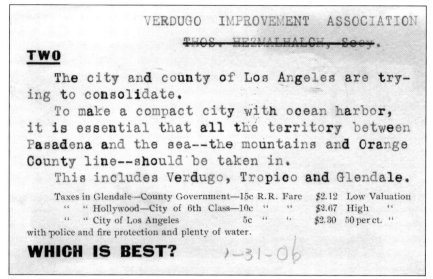

VERDUGO IMPROVEMENT ASSOCIATION
~~THOS. HEZMALHALCH, Secy.~~

TWO

The city and county of Los Angeles are try-
ing to consolidate.

To make a compact city with ocean harbor,
it is essential that all the territory between
Pasadena and the sea--the mountains and Orange
County line--should be taken in.

This includes Verdugo, Tropico and Glendale.

Taxes in Glendale—County Government—15c R.R. Fare $2.12 Low Valuation
" " Hollywood—City of 6th Class—10c " " $2.67 High "
" " City of Los Angeles 5c " " $2.30 50 per ct. "
with police and fire protection and plenty of water.

WHICH IS BEST? 1-31-06

The Verdugo Improvement Association mailed this anti-incorporation postcard to residents in 1906 to solicit opposition for City of Glendale incorporation that included the small settlement of Verdugo. Settlers in the area east of "A" Street (Adams) along Verdugo Road were reluctant to join in Glendale's incorporation effort but eventually gave in, expanding Glendale's boundary to the east. (Courtesy of the Special Collections Room, Glendale Public Library.)

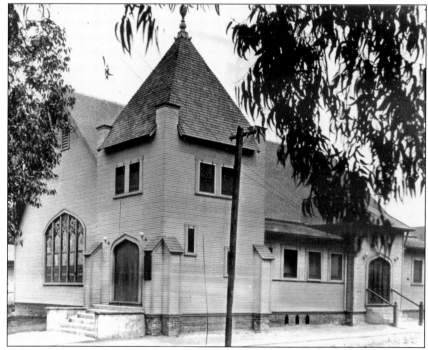

The First Methodist Episcopal Church was located on the northeast corner of Third Street (Wilson Avenue) and Dayton Court (near Everett Street), and was dedicated in 1906. From 1903 until the new church was finished in 1906, meetings were held in the second-story hall of a store building at Third Street and Glendale Avenue. (Courtesy of the Special Collections Room, Glendale Public Library.)

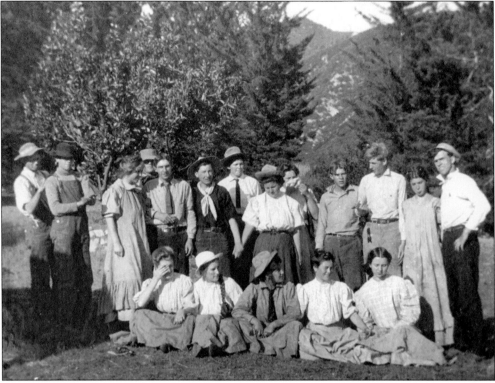

The Glendale Union High School Class of 1907 enjoys an out-of-town party. The photo was published in the 1907 *Stylus*, the school's yearbook. By 1907, 115 pupils were enrolled in Glendale Union High School. (Courtesy of the Glendale Unified School District.)

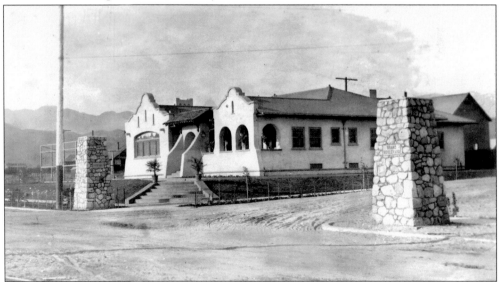

Located at the northeast corner of Brand Boulevard and Wilson Avenue, the Glendale Country Club, shown here in 1907, was built by Leslie C. Brand to serve as the center for Glendale's early social functions. Brand was considered the president and primary patron of the club. (Courtesy of the Special Collections Room, Glendale Public Library.)

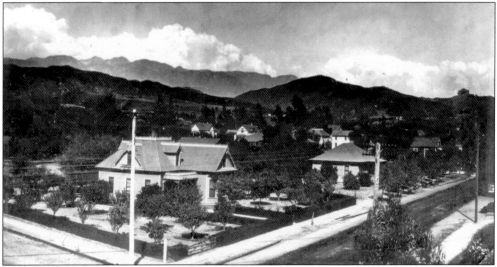

This area around South Verdugo Road, shown here in 1907, was first settled in 1883 and was known as "Verdugo." It included the residences of some of Julio Verdugo's grown children and grandchildren, including his other daughter Maria. (Courtesy of the Special Collections Room, Glendale Public Library.)

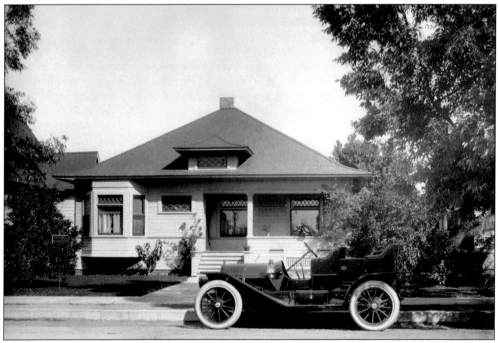

This photo of the east Broadway home of Dr. Raymond E. Chase was taken in 1908. Dr. Chase's parents came to Glendale in 1883 from New York State and the family were among Glendale's early settlers. After graduating from the University of Southern California in 1901, Dr. Chase moved his practice to Glendale and became the health officer for the new city board of trustees, serving for 12 years. He was also the early doctor to the members of the Verdugo family. In 1920, he built a more modern home along Orange Street. (Courtesy of the Special Collections Room, Glendale Public Library.)

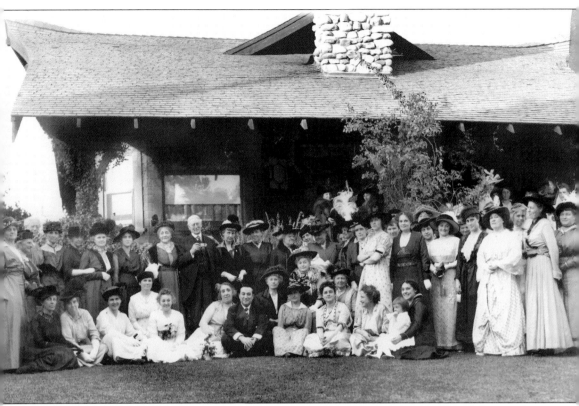

Members of the Tuesday Afternoon Club pose for a group portrait c. 1908. The club started in 1898 with small meetings in the homes of wives of prominent Glendale men. The women's group grew into a large organization and a force in the city's development over the years. The club helped fund the first library in Glendale. (Courtesy of the Special Collections Room, Glendale Public Library.)

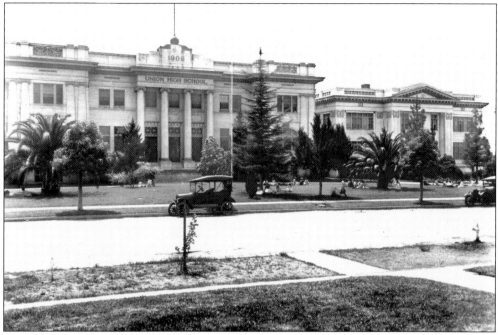

The first Glendale Union High School was quickly outgrown and a new campus was needed. Constructed in 1908, the second campus was located at Harvard and Louise Streets, the site of today's central library. This c. 1928 photo shows the campus during its transition from high school to junior college. (Courtesy of the Seaver Center for Western History Research, Los Angeles County Museum of National History.)

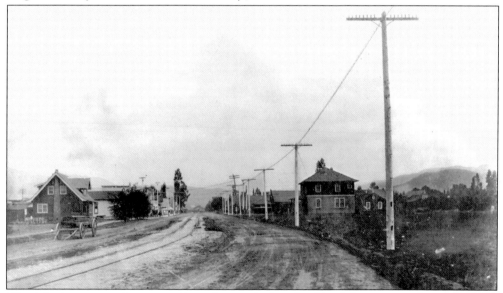

Glendale Avenue was known as Crow Avenue before the Glendale town site days and before that as Camino del Astradero during the rancho days of the Verdugos. This 1908 photo looks north from Harvard Street showing the unpaved, dusty road with railroad tracks in the center. By 1908, this former town hub was losing to Brand Boulevard and Broadway as the center of town. (Courtesy of the Special Collections Room, Glendale Public Library.)

Organized in 1907, the Holy Family Catholic Church, shown here in 1909, was constructed in 1908 on Lomita Avenue and was lead by Rev. James O'Neil from Boston. By 1920, the congregation had 300 families and the next year they built an impressive new church. (Courtesy of the Special Collections Room, Glendale Public Library.)

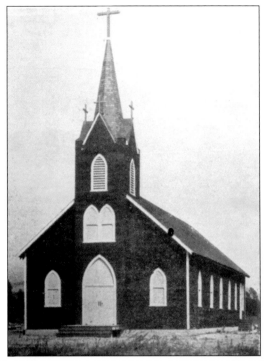

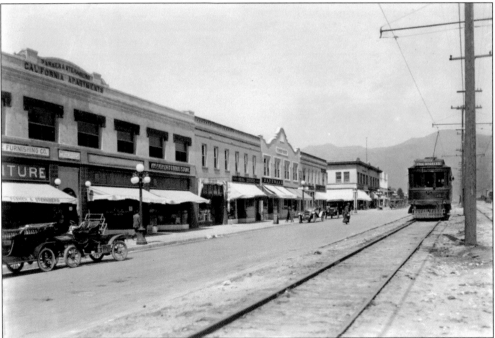

This is Brand Boulevard in 1909 looking north at the intersection with Broadway on the left. An unpaved Brand Boulevard was lined with five-globe-style street lamps. Brand Boulevard eventually lined both sides of the streetcar line and became the commercial hub of the city. Automobile traffic was light back then, but by the 1920s automobiles, streetcars, and pedestrians were competing with each other. (Courtesy of the Special Collections Room, Glendale Public Library.)

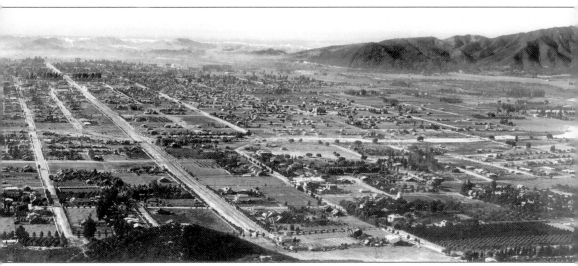

This panoramic view looks south over the Glendale area from the Verdugo Mountains with Griffith Park in the background. The northern terminus of Brand Boulevard is shown in the foreground with the tree-lined Casa Verdugo to the left. By this time the developing area to the north of Glendale and surrounding the Casa Verdugo restaurant became know as the community of Casa Verdugo for the portion around north Brand Boulevard. The area west of Central and Pacific Avenue around Kenneth Road became known as North Glendale. Both areas were part of Los Angeles County at the time this photo was taken by B.D. Jackson in 1908. (Courtesy of the Special Collections Room, Glendale Public Library.)

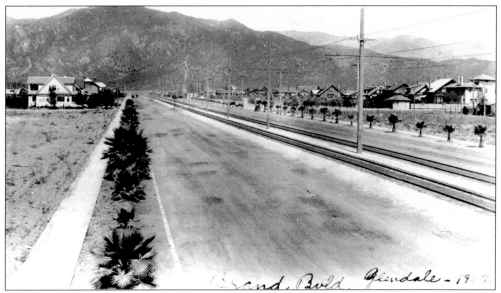

This 1909 photo looking north on Brand Boulevard beyond the commercial district shows an early view of the street's young palm trees. Leslie C. Brand had plans for Brand Boulevard to be lined with them so he enlisted the support of friends and business associates Dan and Arthur Campbell to plant three-foot palm trees from Colorado Boulevard to Mountain Street. These trees eventually grew to be 75 feet high before being cut down. (Courtesy of the Special Collections Room, Glendale Public Library.)

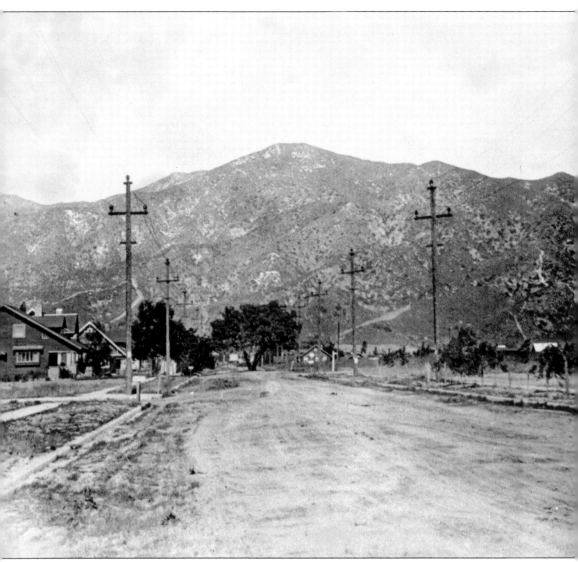

This 1910 photo shows an unpaved Central Avenue north of Doran Street, which was outside of Glendale limits at this time. A tree in the center of the road was later removed. In the settlement days Central Avenue was know as the old highway leading to the Sepulveda and Sanchez adobes and later appropriately named Central. (Courtesy of the Special Collections Room, Glendale Public Library.)

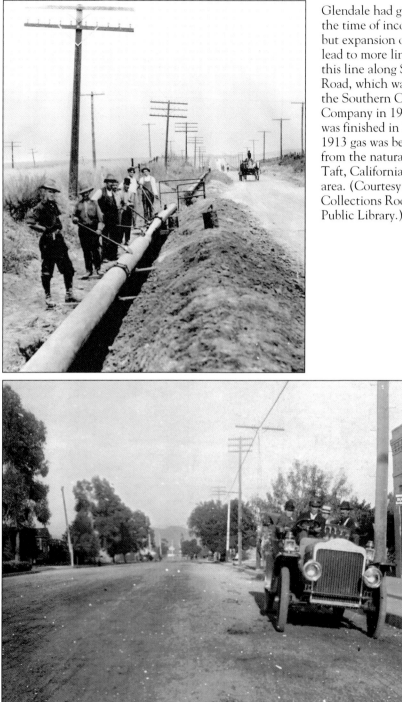

Glendale had gas service by the time of incorporation but expansion of the region lead to more lines, including this line along San Fernando Road, which was installed by the Southern California Gas Company in 1910. The line was finished in 1912, and by 1913 gas was being transported from the natural gas fields near Taft, California, to the Burbank area. (Courtesy of the Special Collections Room, Glendale Public Library.)

In this 1908 photo, land surveyors head to work in expanding Glendale from the office of Edward M. Lynch, who was elected to the city engineer post in 1908 and served until he resigned in 1918. This view looks east on Broadway from 150 feet west of Isabel Street. (Courtesy of the Special Collections Room, Glendale Public Library.)

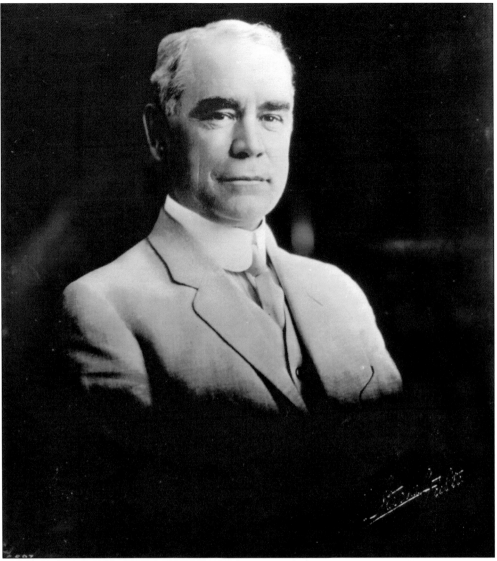

Leslie C. Brand, shown here c. 1910, played an instrumental role in Glendale's development history. Born in Missouri in 1859, he spent much of his young adult life in Texas. He came to California in 1886 where he continued his work in the title insurance business, becoming one of the founders of Title Guarantee and Trust Company with offices in Los Angeles. He began to speculate in real estate first in Pomona and the San Fernando Valley, and worked with Henry Huntington to bring the Pacific Electric to town. He also founded the Home Telephone Company, bringing the first telephone service to Glendale and the San Fernando Valley. He owned three water companies and one electric company that provided water and electricity to the valley before the city was able to provide these services. In 1905, he started the First National Bank of Glendale and in 1907 founded the Glendale Country Club. He died in 1925. (Courtesy of the Special Collections Room, Glendale Public Library.)

The Brand family butler serves beverages on the tennis court at El Miradero c. 1910. (Courtesy of the Special Collections Room, Glendale Public Library.)

Friends of the Brands sit along the front steps of the Brand Lodge on the property of El Miradero around 1910. The lodge was used for family, social, and community gatherings. (Courtesy of the Special Collections Room, Glendale Public Library.)

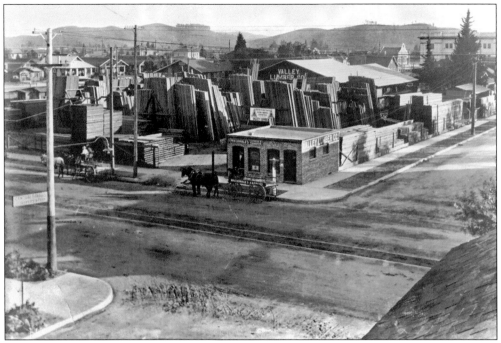

Located at the southeast corner of Maryland Avenue and Broadway in the center of town, the Valley Lumber Company site also included McDonald's Express, Transfer and Storage shown in the foreground of this 1911 photo. The company moved to Los Feliz and became Bentley's Lumber in the 1920s. Glendale Union High School is seen in the background. (Courtesy of the Special Collections Room, Glendale Public Library.)

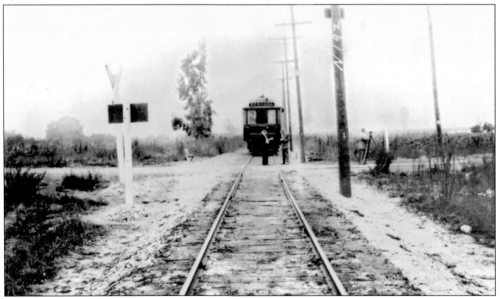

In 1911, the Pacific Electric extended its service by running a connecting line from Glendale to Burbank along a right-of-way that would become Glenoaks Boulevard. This is the Pacific Electric crossing at Pacific Avenue. (Courtesy of the Special Collections Room, Glendale Public Library.)

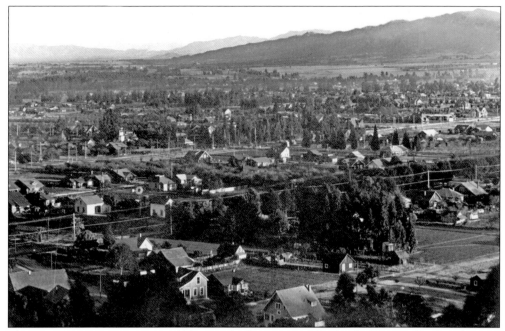

This 1912 panoramic view is of Tropico looking toward Burbank. Having fought advances from Glendale and Los Angeles, Tropico became an independent incorporated city in 1911; however, there were constant back and forth ballot measures after incorporation to become a part of Glendale, which finally came true in 1918. (Courtesy of the Special Collections Room, Glendale Public Library.)

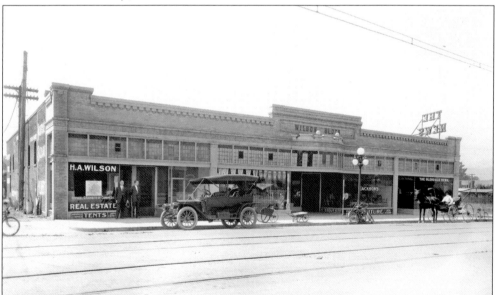

Built by Harry A. Wilson, this building on east Broadway between Louise and Kenwood Streets, shown here in 1912, housed his real estate office, Jackson's Furniture, Hartfield Hardware Company, the Royal Baking Company, the chamber of commerce, and the *Glendale News*. In 1912, Wilson built one of the first apartment houses in Glendale. It contained about four units. (Courtesy of the Special Collections Room, Glendale Public Library.)

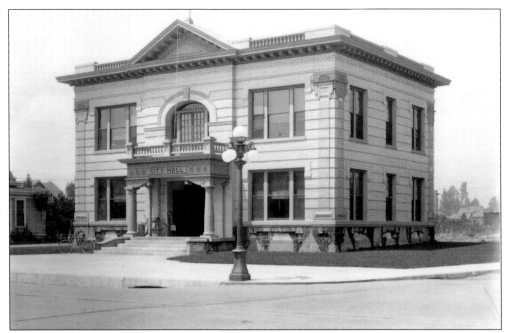

On March 1912, the first Glendale City Hall was completed at the northeast corner of Broadway and Howard Street and anchored the center of municipal government from this point forward. The building was enlarged in 1922 to almost twice the original size and included an annex. In 1909, the city controlled its own municipal light service and in 1914, under some opposition, purchased several existing water companies to form a municipal water department. (Courtesy of the Special Collections Room, Glendale Public Library.)

Verdugo Road was appropriately named since it was the principal road during the rancho days leading from Los Angeles to La Canada. This 1912 photo shows its northern portion along the site of today's Glendale College heading toward La Canada. Today the old Verdugo Road of the rancho days has been bisected several times by the Glendale Freeway. (Courtesy of the Special Collections Room, Glendale Public Library.)

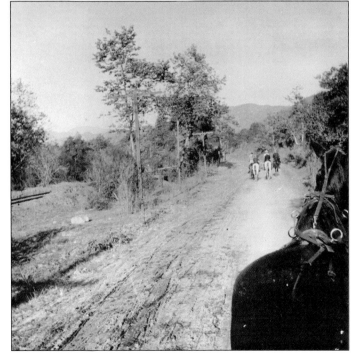

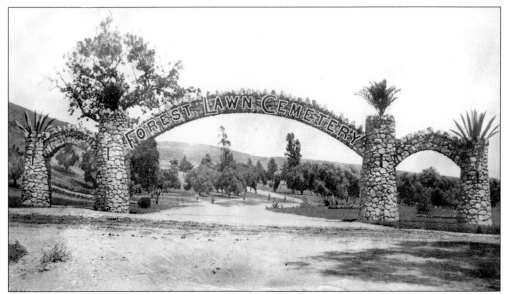

By 1930, Forest Lawn made Glendale a notable location. Founded in 1906 on 100 acres of land owned by a daughter of Andrew Glassell, the cemetery has grown substantially in grandeur with English gothic architecture, expansive lawns on rolling hills, and grand artwork recreations. This photo shows the original Forest Lawn gate in 1912. (Courtesy of the Special Collections Room, Glendale Public Library.)

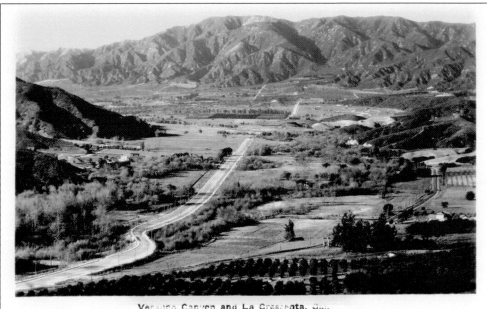

Heading north from its intersection with Verdugo Road, Canada Boulevard curves sharply as it crosses the creek of Verdugo canyon. In the foreground of this 1912 photo of Verdugo Canyon and La Crescenta are orchards where Glendale College is today. The wooded land to the left is Verdugo Park, a popular picnic destination in those times, with two different rail lines running to it from Glendale and Los Angeles. Beyond are the wild, sage-covered heights of the Crescenta Valley. (Courtesy of the Special Collections Room, Glendale Public Library.)

This 1912 advertisement is for a residential area called "Verdugo Park," which was never realized until new owners in the early 1920s opened up the Verdugo canyon area to residential subdivisions. (Courtesy of the Special Collections Room, Glendale Public Library.)

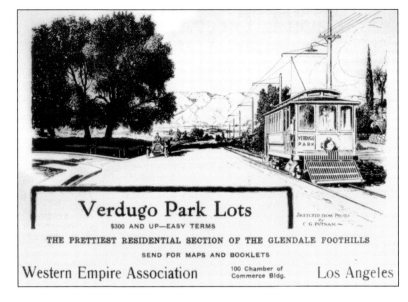

Verdugo Park Lots

$300 AND UP—EASY TERMS

Sketched from Photo by C G Putnam

THE PRETTIEST RESIDENTIAL SECTION OF THE GLENDALE FOOTHILLS

SEND FOR MAPS AND BOOKLETS

Western Empire Association 100 Chamber of Commerce Bldg. Los Angeles

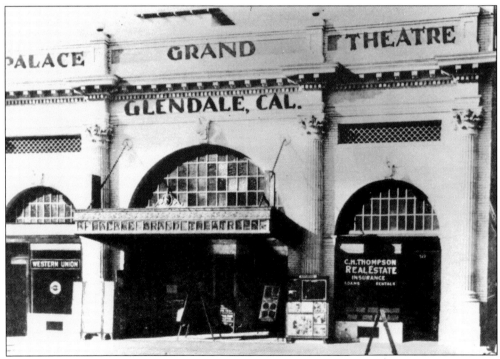

The Palace Grand on Brand Boulevard was opened in 1914 by Henry C. Jensen in the center of Glendale's business district. It housed an early motion picture theatre, a stage, dressing rooms, orchestra pit, an auditorium for vaudeville shows, and a bowling alley in the basement. It had no competition until 1920 when the Glendale Theatre was built. It closed in 1921. (Courtesy of the Special Collections Room, Glendale Public Library.)

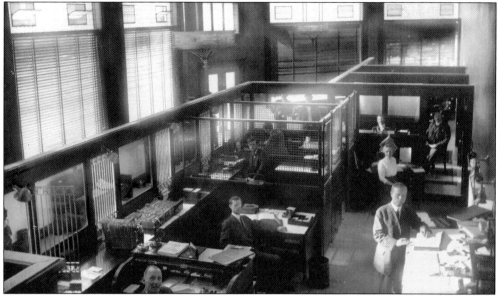

The First National Bank relocated from north of Broadway to the southeast corner of Brand Boulevard and Broadway in a newly constructed three-story building and operated under that name until the bank merged and became the Security Trust and Savings Bank, which built a new six-story building across the street in 1923. This photo shows the First National Bank interior around 1918. (Courtesy of the Special Collections Room, Glendale Public Library.)

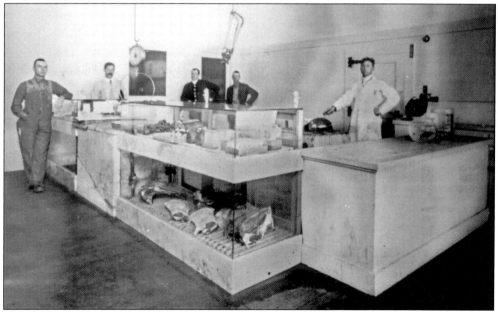

Logan's Espesero De Verdugo was located on the southwest corner of Stocker Street and Central Avenue in Casa Verdugo and likely housed the largest stores in Glendale's valley, offering a large department store, the post office for Casa Verdugo, the Mission Theatre, groceries, a meat market, a hardware store, and a drug store. The large building was destroyed in a fire but quickly rebuilt. This photo shows the butcher shop in the Logan's General Store around 1914. (Courtesy of the Special Collections Room, Glendale Public Library.)

The Tuesday Afternoon Club started the first Glendale library on February 26, 1906 in a rented space, but in 1907 the Glendale City trustees established the library, which moved to a larger space in 1909. The Tuesday Afternoon Club entered into negotiations with the Carnegie Corporation and received a grant for a new library, shown here in 1914, constructed at the corner of Kenwood and Harvard Streets. (Courtesy of the Special Collections Room, Glendale Public Library.)

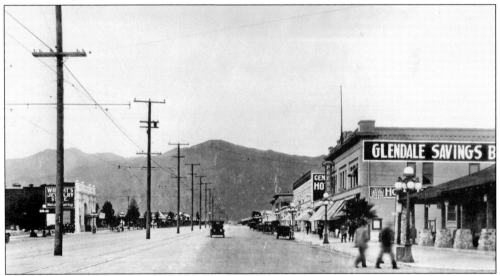

By 1915, Brand Boulevard Pacific Electric tracks were lowered to street level and the streets were paved. Brand Boulevard, shown here north of Broadway, was made wide for the center electric lines, the streetcars, automobiles, and pedestrians. The former First National Bank was changed to the Glendale Savings Bank in 1913 and behind the bank is the Glendale Hotel formerly known as the Woods Hotel constructed in 1907. (Courtesy of the Special Collections Room, Glendale Public Library.)

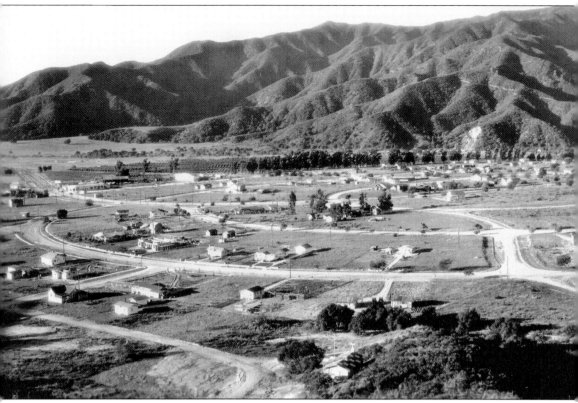

This photo of early Montrose looking southwest was taken in 1915. In 1913, 300 acres in the lower portion of the Crescenta Valley were subdivided and streets were laid out in the shape of a rose in honor of the new town's name. The subdivision included curving streets and opened with a barbeque celebration to attract potential purchasers. The Glendale and Montrose Railway, an electric trolley, ran up Verdugo canyon and brought home seekers from Glendale and Los Angeles. The line of eucalyptus trees below the curving streets marks Honolulu Boulevard, named for the boyhood home of one of the developers. In the far left of the photo is the intersection of Honolulu Boulevard and Verdugo Road. The white curved building shows the Montrose Hardware and Grocery Store built in 1914 as the first business in what is now a thriving commercial district that still retains its small town flavor. (Courtesy of the Special Collections Room, Glendale Public Library.)

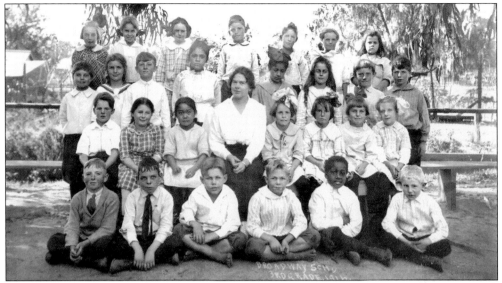

The Broadway School, which stood on the same site as today's John Marshall Elementary School, received its name in 1912, lasting to 1926. Prior to 1912 the school was known as the Fourth Street School and prior to 1909 was named Glendale School. In the beginning, from 1887 to 1892, the school was named Verdugo School. This photo shows the third grade class in 1916. (Courtesy of the Glendale Unified School District.)

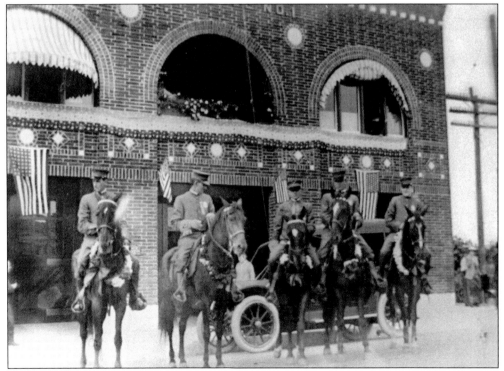

These early Glendale police officers prepare for a parade in front of the original police and fire headquarters. In 1916, Glendale police and fire services were separated. (Courtesy of the Special Collections Room, Glendale Public Library.)

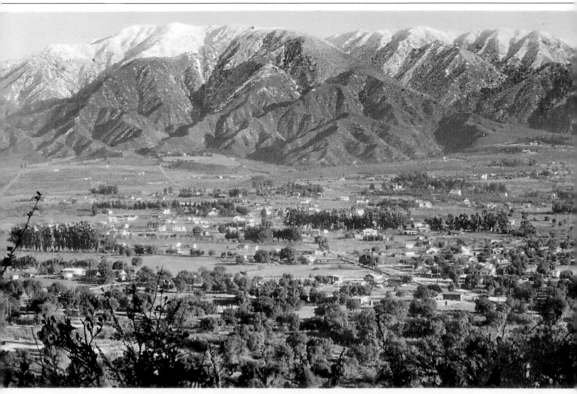

Winter in La Crescenta, Calif.

This c. 1916 winter photo shows the center of the Crescenta Valley, looking north. Oak-studded meadows are seen in the foreground, at the shaded and wetter north side of the Verdugo Mountains. Above that is the La Crescenta town center, marked by rows of eucalyptus trees planted as windbreakers against the frequent and fierce Santa Ana winds that caused so much destruction in early valley history. Farther up the slope, above what is now Foothill Boulevard, is the rocky, sage-covered land stretching up to the steep face of the San Gabriel Mountains. On the right side of the photo, the land begins to slope up to Brigg's Terrace, site of the first homestead in the valley in 1871. (Courtesy of the Special Collections Room, Glendale Public Library.)

Having outgrown its site on Dayton Court, the First Methodist Episcopal Church acquired a new site at the southeast corner of today's Wilson Avenue and Kenwood Street. A new church was built in 1916, designed by local architect Arthur Lindley. (Courtesy of the Special Collections Room, Glendale Public Library.)

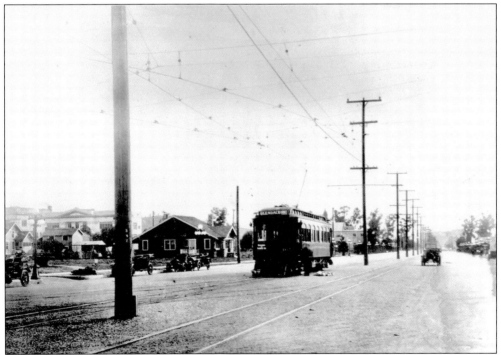

This photo of Brand Boulevard and Harvard Street looking south was taken in 1918. Glendale Union High School is seen in the background to the left. The Pacific Electric car is traveling north. (Courtesy of the Special Collections Room, Glendale Public Library.)

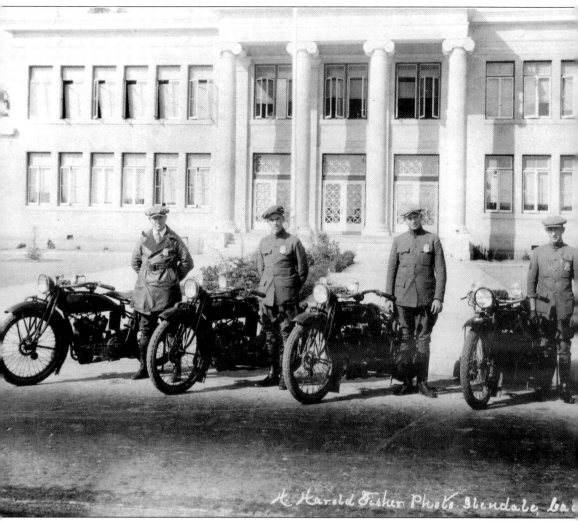

Officers of the Glendale Police Department pose in front of Broadway School in 1919 with their Indian motorcycles used to patrol the residential areas. With the annexation of Tropico in 1918, the Glendale Police Department was formed with its own headquarters at city hall and a force of 18 men. (Courtesy of the Special Collections Room, Glendale Public Library.)

Four

GLENDALE BOOMS WITH SOUTHERN CALIFORNIA
1919–1929

After World War I and the annexation of both the City of Tropico and the community of West Glendale, a new, larger Glendale was on a clear path of expansion. This expansion coincided with the tremendous growth across Southern California of strong regional industries such as aviation, movies, tourism, oil, and port development. Glendale's prime location in the region made it ideal for residential growth since it was on the outskirts of Los Angeles and its vast and vacant hillsides provided an attractive setting for homebuilding.

Los Angeles city was also on a path of expansion, and there were threats of Glendale being annexed to Los Angeles if Glendale could not provide all its city service needs. But the business community of Glendale had strengthened and would not allow annexation. The Glendale Chamber of Commerce began in the teens but became a major force in Glendale development in the early 1920s. Another powerful business organization was the newly formed Glendale Realty Board as real estate development had become big business for the city. Real estate agencies abounded, with offices along east Broadway and Brand Boulevard. The 1930 Census shows a greater than average percentage of real estate occupations compared to other cities of its size. Between 1921 and 1926, over 50 subdivisions were advertised in Glendale newspapers. Real estate promotion was high, many ads grandiosely overstating the advantages of the city, although a true highlight was the foothill region's beauty. Unfortunately, several Glendale subdivisions, as in many others throughout Southern California, were known to include deed restrictions prohibiting sale to certain ethnic and racial groups. The United States Supreme Court invalidated such racial/ethnic-based deed restrictions decades later.

The City of Glendale's growth meant the need for a new form of government, and voters ratified the new city charter in 1921. Also needed was a city plan to guide growth in a positive direction. The plan gave extra attention to controlling traffic circulation and the need to acquire land for future parks. The city plan determined land uses, essentially incorporating the

current land use pattern that had developed on its own over time. In 1921 the city also adopted one of the state's first zoning ordinances and in 1922 the first city manager was appointed.

Real estate agents and the general business sector were aware that the city needed to attract new residents in order to further increase business. In 1922 the Glendale Chamber of Commerce sent out a solicitation for a new slogan for Glendale. In the teens, the chamber adopted the name "Jewel City" for Glendale to attract attention, but now the chamber needed a message as well as a name. The chamber claimed that the U.S. Census Bureau reported that Glendale was the fastest growing city in America between the 1910 and 1920 Census and therefore adopted "The Fastest Growing City in America" as its new slogan. Indeed, Glendale had grown by 393 percent from 2,746 in 1910 to 13,536 in 1920 and did have the highest growth rate among mid-size California cities. In earlier times, older cities such as Fresno and Oakland grew by more than 400 percent in a 10-year period. Much of Glendale's growth was attributed to more people moving into the area but was also due to annexations in that period, including the city of Tropico, West Glendale, and the Verdugo Woodland area, which increased the land area of the city by more than three times its size in 1910.

However, the more significant period of growth was from 1920 to 1930 when the city grew by 49,200 people. By this time Glendale was no longer the fastest growing city in American or even in California. Other local cities, including Beverly Hills, Burbank, and Inglewood had a larger growth rate than Glendale in the 1920s. The chamber stopped using the "Fastest Growing City in America" slogan by the early 1930s, but it persisted in the community for decades afterward. The 1920s represented the most significant period of growth for the city in terms of charting the physical layout out that can be seen today.

Brand Boulevard came of age as not just a shopping district but also an entertainment center with several movie houses, including the grand new Alexander Theatre, showing vaudeville and silent films. The regional roadway system planned by Los Angeles County integrated Glendale with the expanding region. Glendale acquired its first park in 1922; Patterson Park's name was later changed to Fremont Park. Aviation gave Glendale recognition with the completion of Grand Central Air Terminal in 1929 offering the first cross-country air flight service. Continuing annexations during the 1920s expanded Glendale's size. Nearly all annexations in the 1920s were in the northwestern portion of today's city, including annexation of Casa Verdugo. The decade ended abruptly for Glendale as it did for the whole country with the stock market crash of 1929. Many Glendale residents, including wealthy real estate developers and big business owners, were badly affected.

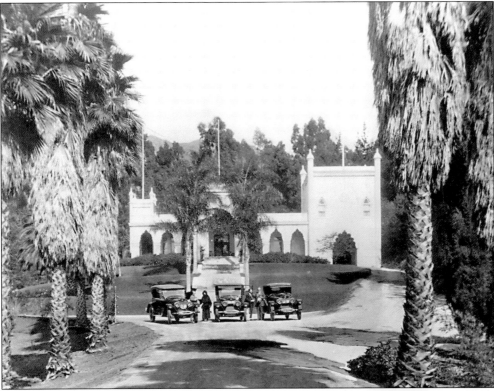

Mrs. Leslie C. Brand and friends pose in front of El Miradero, the Brand home, in 1923. The Brands had no children but devoted a great amount of attention to their nieces and nephews. Palm trees lined the home's driveway to Mountain Street. (Courtesy of the Special Collections Room, Glendale Public Library.)

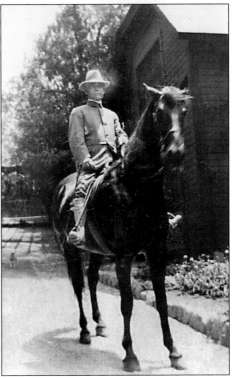

Leslie C. Brand was also known for his non-business passions, which included horseback riding. He was also a fan of horse racing. (Courtesy of the Special Collections Room, Glendale Public Library.)

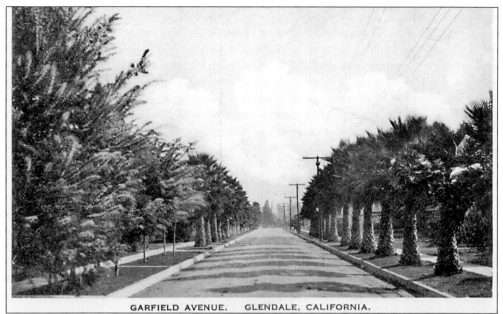

GARFIELD AVENUE. GLENDALE, CALIFORNIA.

A c. 1922 tourist postcard depicts a tranquil Garfield Avenue streetscape in early Glendale. New residents would write back to relatives mostly in the Midwest telling of nice weather conditions and lovely streets. (Courtesy of the Special Collections Room, Glendale Public Library.)

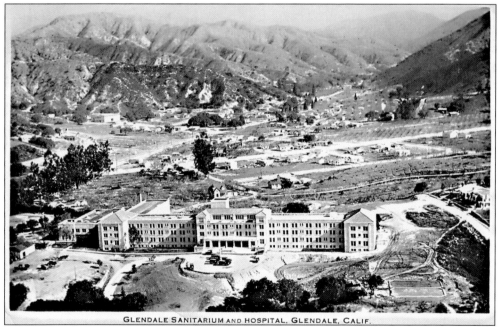

GLENDALE SANITARIUM AND HOSPITAL, GLENDALE, CALIF.

In 1922 the Glendale Sanitarium on Broadway moved to a bigger, more modern facility on the hills above Glendale in an expansive five-story, fireproof building. The new Glendale Sanitarium and Hospital was advertised as the temple of health. By 1927, the number of beds had grown from 150 to 250. Glendale Sanitarium later became Glendale Adventist Medical Central after a series of expansions. (Courtesy of the Special Collections Room, Glendale Public Library.)

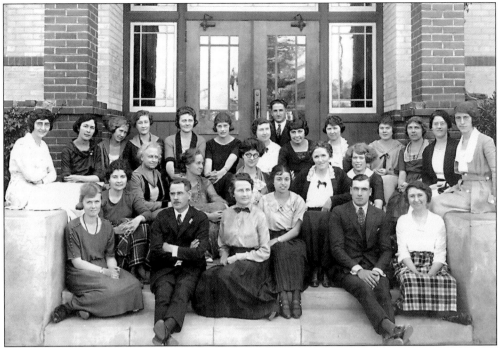

At the time this photo of the faculty of Wilson Intermediate School was taken in 1922, this school on Wilson Avenue and Jackson Street and Roosevelt School were the two intermediate schools in Glendale. At the start of the 1922 school year, almost all Glendale schools found themselves filled beyond capacity. (Courtesy of the Special Collections Room, Glendale Public Library.)

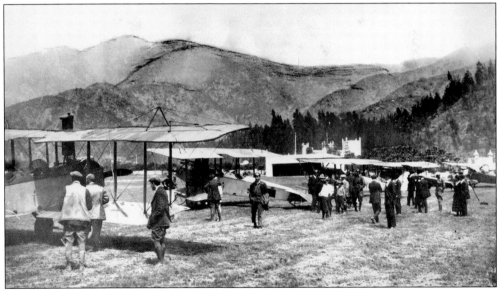

On April 1, 1921, Leslie C. Brand hosted a "fly in" party at his home inviting guests to fly into Glendale and land on his airfield in front of his home. Movie stars of the silent film era and other high society guests attended the party. (Courtesy of the Special Collections Room, Glendale Public Library.)

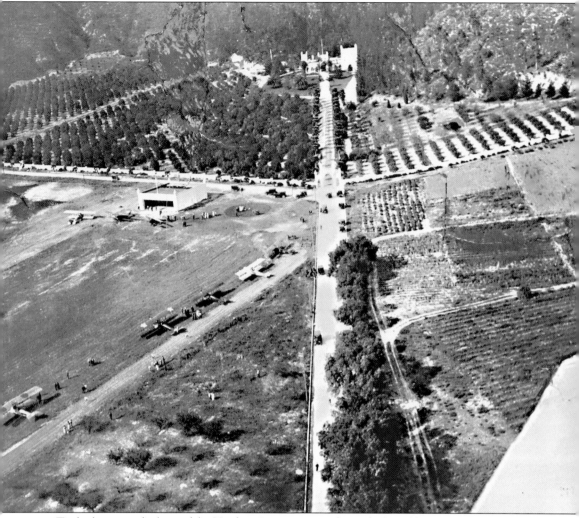

Tucked away at the base of the Verdugo Mountains at the end of an old county road that divided the lands of Rafaela Verdugo and David Burbank and now appropriately named Grandview Avenue sits the home of Mr. and Mrs. Leslie C. Brand, as shown in this aerial view from 1921. Mr. Brand's interest in aviation began in 1919 when he had an early aircraft manufactured for him. He thought his loyal chauffeur could fly him around but fortunately the chauffer, Mr. Pomeroy, convinced Brand to hire a trained pilot. (Courtesy of the Special Collections Room, Glendale Public Library.)

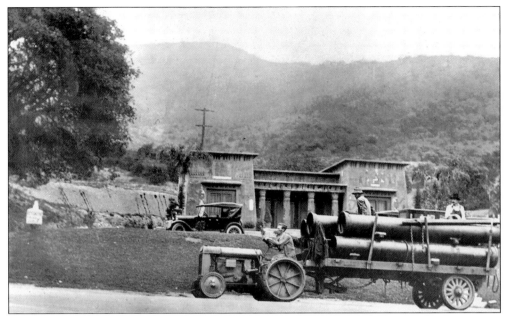

Water pipes are hauled up Verdugo Road in front of the real estate office for the Rossmoyne residential subdivision. The office, located on the southeast corner of Mountain Street and Verdugo Road, was designed in the Egyptian Revival architectural style popular at this time when the tomb of the Egyptian King Tut was discovered. This photo of the "Rossmoyne Egyptian Temple" was taken around 1923. (Courtesy of the Special Collections Room, Glendale Public Library.)

This photo of the Sparr Heights Real Estate Office dates from 1922. The Sparr Heights subdivision and annexation area extended the city's boundary to the north into the Crescenta Valley near Montrose. Named after William Sparr, the millionaire citrus farmer who once owned the land, the residential subdivision was annexed to Glendale to take advantage of municipal water services and road building. Behind the tract office is the first building of the Fremont elementary school. The tract office was eventually donated to the City of Glendale. (Courtesy of the Special Collections Room, Glendale Public Library.)

The Jensen Arcade and Egyptian Village Café was created in 1921. The second floor housed the Egyptian Village Café, a favorite dining spot with an elaborate interior containing long colonnades of fluted columns with pseudo-Egyptian capitals. It closed in 1927 and the Jensen family sold the property in 1936. (Courtesy of the Special Collections Room, Glendale Public Library.)

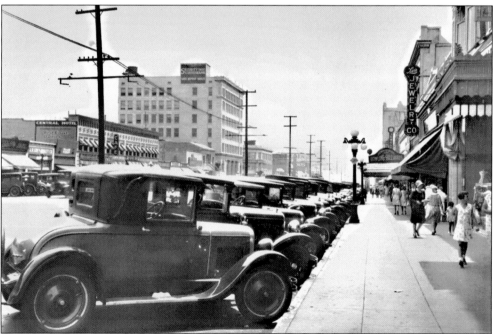

Jensen's Arcade fronted on Brand Boulevard. The old bowling alley of the former Jensen's Palace Grand Shops continued into the 1920s. Shops on the ground floor and the Egyptian Village Café upstairs made this a popular attraction during the 1920s. (Courtesy of the Special Collections Room, Glendale Public Library.)

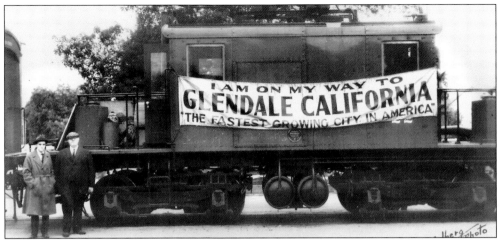

Glendale's popular slogan of the 1920s is proudly displayed on this train leaving Montrose for Glendale. (Courtesy of the Special Collections Room, Glendale Public Library.)

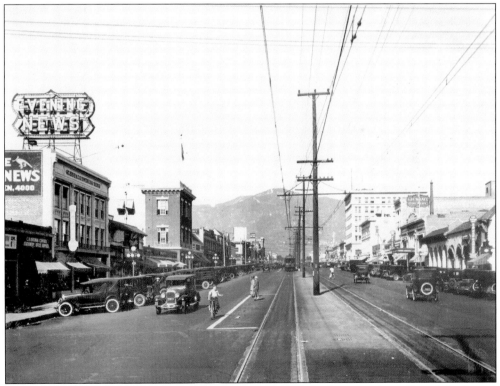

This photo shows the hub of Glendale activity, c. 1927, looking north on Brand Boulevard toward the intersection with Broadway. The six-story Security Trust and Savings Bank to the right and the three-story Pacific Telephone and Telegraph building on the left were the tallest buildings at the time. The Glendale Theatre is seen on the right. (Courtesy of the Special Collections Room, Glendale Public Library.)

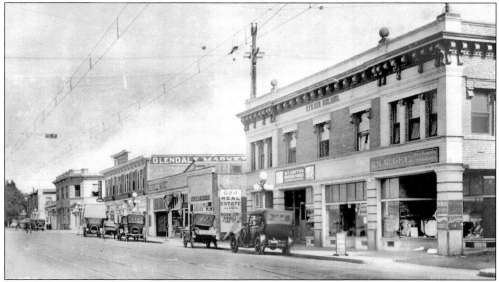

This 1921 street scene looking east along Broadway toward the intersection with Glendale Avenue shows the two-story second location for the Bank of Glendale with a rounded façade seen toward the end. The two-story Filger Building in the foreground is now the site of the county courthouse. (Courtesy of the Special Collections Room, Glendale Public Library.)

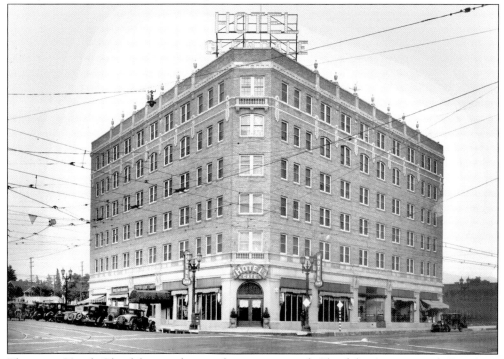

The new Hotel Glendale on the northeast corner of Glendale Avenue and Broadway constructed by Charles Ingledue represented the enterprising efforts of businessmen on the east side to bring importance back to this location. Designed by Arthur Lindley in the Renaissance Revival style, the hotel opened on June 21, 1924. It awkwardly contained a restaurant in the basement. (Courtesy of the Special Collections Room, Glendale Public Library.)

WEST ON CHESTNUT AVENUE. GLENDALE, CALIFORNIA.

This postcard view of an early Chestnut Avenue street scene was taken around 1924. (Courtesy of the Special Collections Room, Glendale Public Library.)

Union Metal Lamp Standard
Design Nº 1747
Central Ave, Glendale Calif

This photo, taken in 1924 by Union Metal of Ohio looking south from Lomita Avenue, is of south Central Avenue and proudly illustrates the ornate new lampposts that were being installed throughout the commercial areas of the city. Other ornate lampposts installed during the same time in the residential and commercial area contained the ancient "swastika" symbol as a decorative border, which is often mistaken for the Nazi swastika. (Courtesy of the Special Collections Room, Glendale Public Library.)

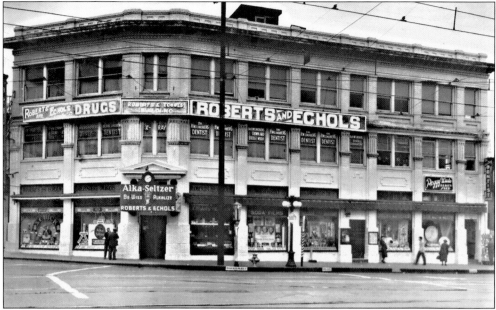

By 1926, the former First National Bank at the southeast corner of Brand Boulevard and Broadway had moved out. Roberts and Echols Drug Store moved in downstairs, with a dentist office upstairs. (Courtesy of the Special Collections Room, Glendale Public Library.)

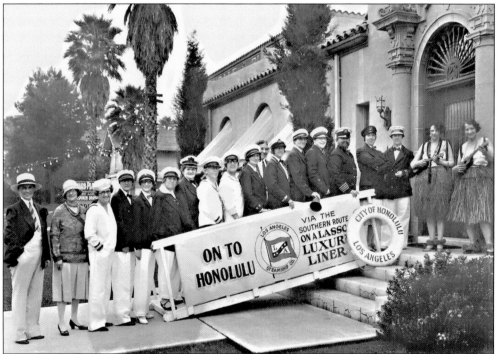

Members of the Tuesday Afternoon Club dress up as men for a play about sailing to Honolulu. They pose in front of their clubhouse at the corner of Central Avenue and Lexington Drive, which was designed by Alfred Priest and constructed with the help of Leslie C. Brand. (Courtesy of the Special Collections Room, Glendale Public Library.)

Peter L. Ferry, an early Glendale resident, leading contractor, and civic leader, looks over the paving job he did on the widening of Glendale Avenue in 1924. He stands just south of the intersection with Colorado Boulevard looking north. (Courtesy of the Special Collections Room, Glendale Public Library.)

Kenneth Road dates back to the 1880s as a dirt road that provided access across the foothills for the residents of the few farms that dotted the area. In the teens it increasingly became the site where the region's wealthy chose to build their homes, and by the 1920s, with subdivision activity booming, small homes designed in Spanish, English, Mediterranean, and French Revival styles that often incorporated romantic or fairytale themes completed the development pattern. (Courtesy of the Special Collections Room, Glendale Public Library.)

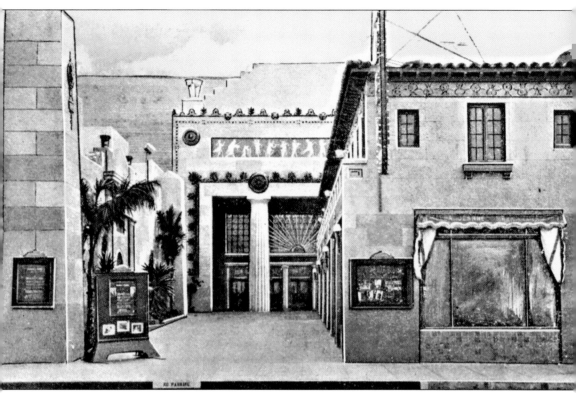

When the Alexander (later known as the "Alex") Theatre was completed in 1924, it became Glendale's most expensive theatre costing 25¢ for a double feature film. Arthur Lindley and Charles Selkirk were the architects who designed the theatre for Fox Theatres in a fantasy Egyptian and Greek Revival style. A series of alterations in the 1940s changed the look of the theatre into an Art Deco movie palace. (Courtesy of the Special Collections Room, Glendale Public Library.)

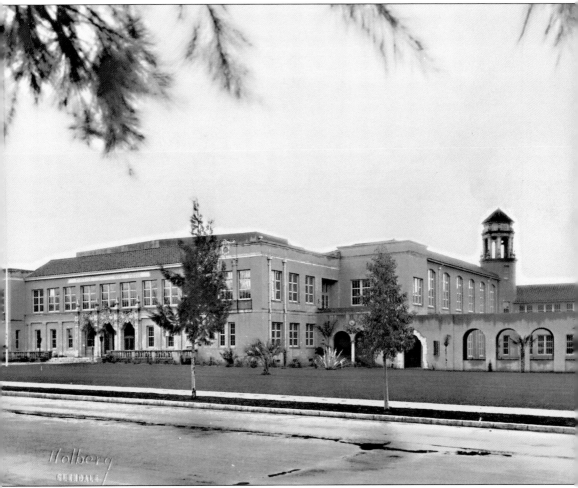

By 1918, the Glendale Union High School on Harvard Street was outgrowing its classroom space and plans were made for a larger campus. Disputes over the tax burden of a new school slowed construction, but by 1924 the brand new campus of the third Glendale High School on Broadway and Verdugo Road as shown in this portrait was complete and became the pride of the community. (Courtesy of the Glendale Unified School District.)

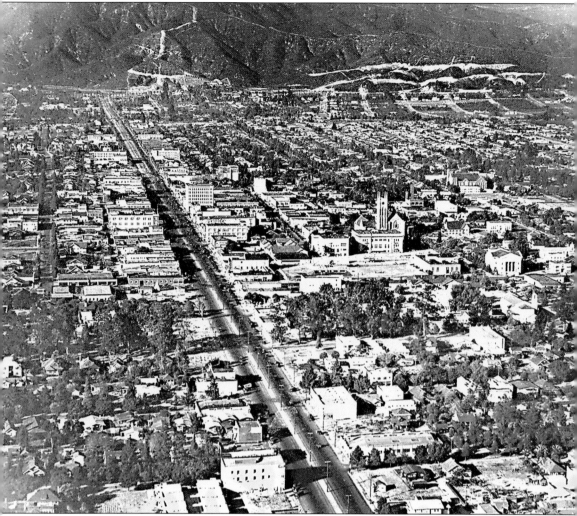

By 1924, Glendale's shape had taken form with Brand Boulevard clearly evolving into the town's main street. Churches clustered around Harvard Street and Broadway. High-rise offices clustered around Brand Boulevard and Broadway; the original residential neighborhoods that were established in 1905 began to fill out by 1925. This period also marked a quick rise in apartment construction while new neighborhoods were forming along the foothill areas, as can be seen in this aerial view with the Bellhurst and Rossmoyne subdivisions in the northeast. No freeways existed in the region although San Fernando Road (not visible) served as a state highway. (Photo from the Security Bank collection, courtesy of the Special Collections Room, Glendale Public Library.)

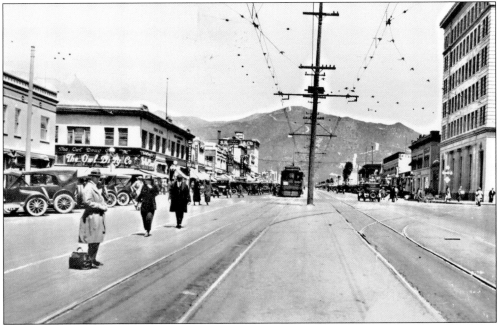

By the late 1920s, commercial activity was heavy on Brand Boulevard and Broadway and modes of transportation competed with each other. (Courtesy of the Special Collections Room, Glendale Public Library.)

Pacific Electric offered bus service from its Brand Boulevard streetcar line to the Rossmoyne subdivision. This photo of Pacific Electric Bus No. 25 was taken in front of Nibly Park, a playground dedicated to the City of Glendale by the Haddock-Nibly Investment Company responsible for developing the Rossmoyne neighborhood. (Courtesy of the Glendale Historical Society.)

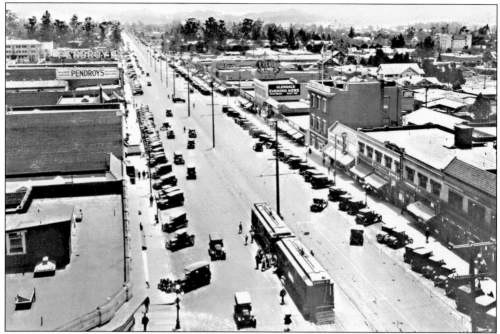

This photo of south Brand Boulevard looking south from the intersection with Broadway shows that commercial activity was light and homes more prominent until the 1930s when automobile and motorcycle dealerships replaced the larger homes on south Brand Boulevard. (Courtesy of the Special Collections Room, Glendale Public Library.)

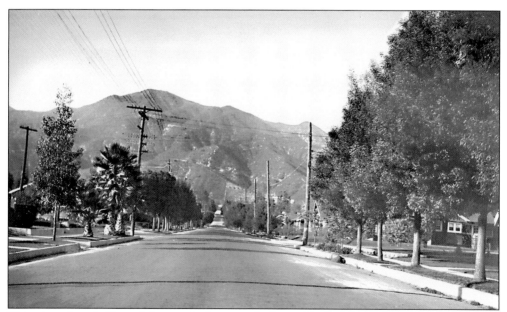

This view of north Central Avenue looking north above Glenoaks was taken in 1928. With the annexation of Casa Verdugo in 1926, this area became the newest part of Glendale and ended the era of great expansion until the city annexed the La Crescenta area in the 1950s. (Courtesy of the Special Collections Room, Glendale Public Library.)

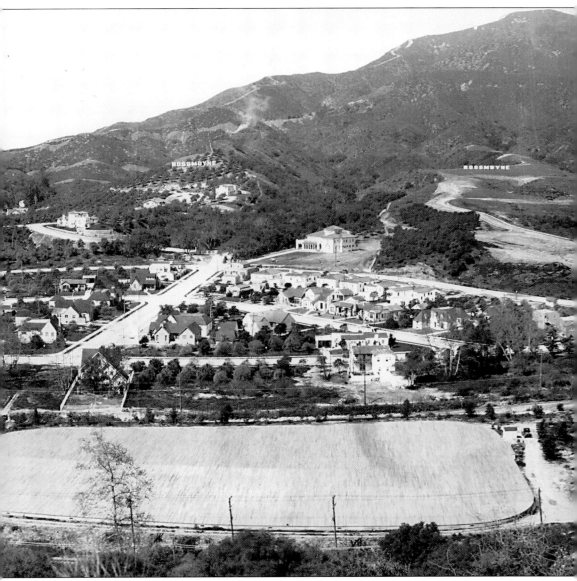

The Rossmoyne development by the Haddock-Nibly Investment Company of Los Angeles marked one of Glendale's most thought-out subdivisions with plans for winding streets, Spanish architecture, commercial centers, a park, and a junior college among an optimal suburban setting. It was also the most rapidly developed subdivision with most of the homes constructed soon after the subdivision was laid out. Within three years after this photo was taken in 1927, most of the homes in this area were built. "Homeland," the large Italian-style mansion seen to the right was the home of W.F. Markham built in 1926. (Courtesy of the Glendale Historical Society.)

Jessie E. Smith and James A. Robinson pose in front of Smith's home on Kenneth Road. Jessie Smith owned a Ford dealership in Glendale and was president of the chamber of commerce from 1922 to 1923. He also aided in the effort to purchase land for the Oakmont Country Club. James A. Robinson owned Glendale's finest men's clothing store at 114 South Brand Boulevard. (Courtesy of the Special Collections Room, Glendale Public Library.)

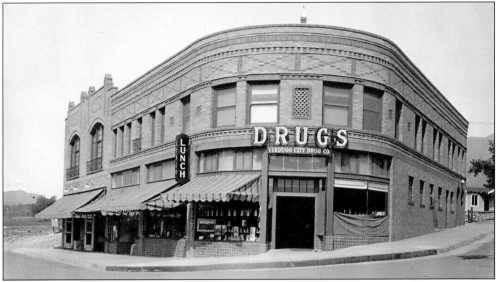

The Verdugo City Drug Store was part of one of the grandest brick buildings in the La Crescenta area. It was built in 1925 by Harry Fowley, who created it as the centerpiece of his 10-acre development "Verdugo Park," which was later changed to "Verdugo City." The name "Verdugo City" survives in the post office across the street. (Courtesy of the Special Collections Room, Glendale Public Library.)

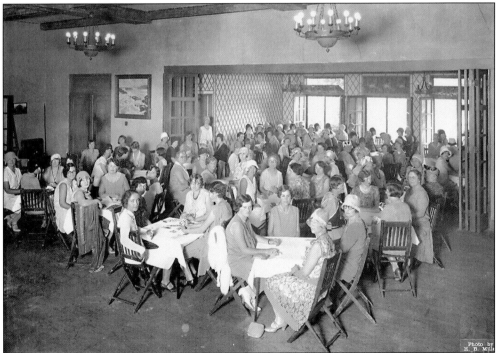

Women of the Tuesday Afternoon Club play cards after a typical luncheon meeting. By 1922, the club had 700 members and several committees dealing with cultural, social, philanthropic, and recreational pursuits appropriate for women of the time. (Courtesy of the Special Collections Room, Glendale Public Library.)

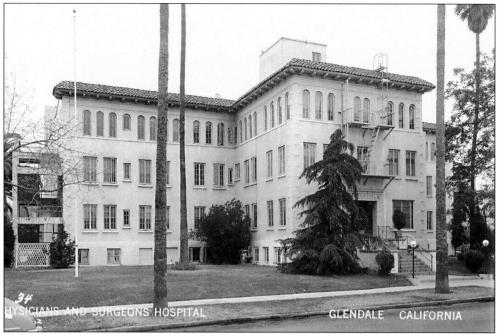

The Physicians and Surgeons Hospital opened in 1926 and is today a part of Glendale Memorial Hospital. (Courtesy of the Special Collections Room, Glendale Public Library.)

Men and women dance in Glenoaks Park in this photo taken in 1927. (Courtesy of the Special Collections Room, Glendale Public Library.)

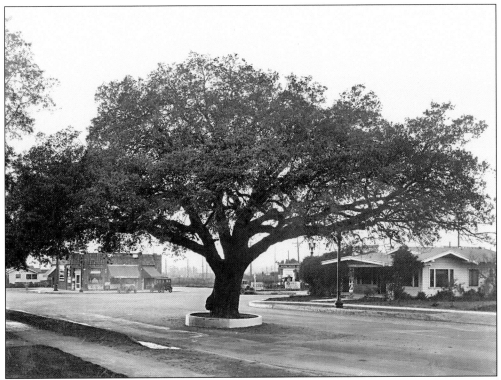

A large oak tree was saved when Pacific Avenue and Burchette Street were paved. (Courtesy of the Special Collections Room, Glendale Public Library.)

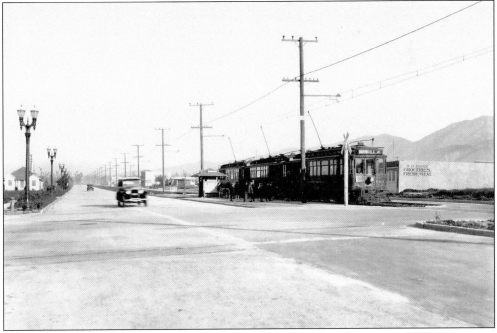

The Pacific Electric streetcar runs along the center of Glenoaks at Western c. 1927, connecting Glendale with Burbank. (Courtesy of the Special Collections Room, Glendale Public Library.)

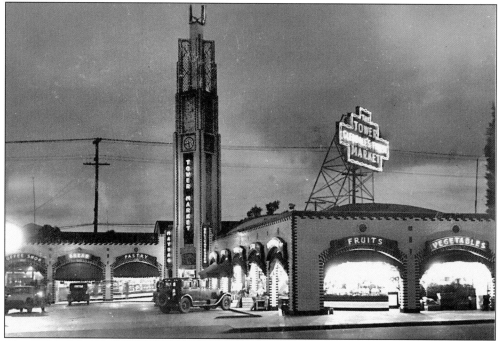

This 1928 photograph showcases the new Tower Market at 413 South Central (and Vine Street). The shopping center offered customers a coffee shop, a bakery, groceries, dry goods, and meats all in one place with convenient, drive-up parking. The lighted rooftop sign reads "Glendale's Finest." (Courtesy of the Special Collections Room, Glendale Public Library.)

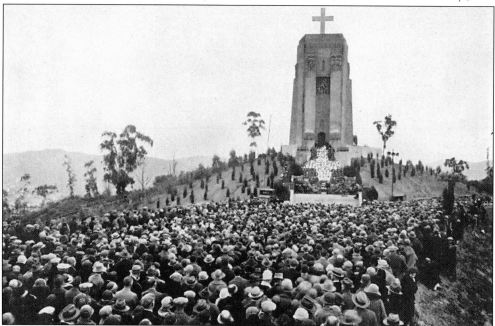

Easter Sunday service was a popular tradition at the Forest Lawn Memorial Park. This Forest Lawn Tower of Legends photo was taken in 1926. (Courtesy of the Special Collections Room, Glendale Public Library.)

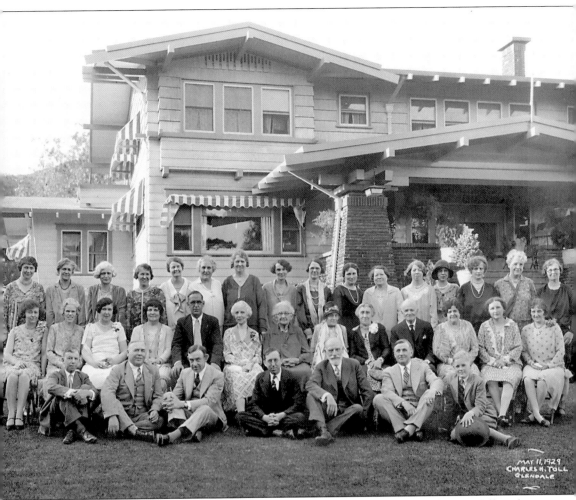

Seated third from the right in this 1929 photo of the Toll House is Charles H. Toll with associates and women from the Tuesday Afternoon Club. This photo was taken three years after the death of Mrs. Eleanor Toll. Both were prominent and highly respected citizens of Glendale. Mr. Toll moved to Los Angeles in 1885 and became vice president of the Security Trust and Savings Bank in 1906. The couple moved to Glendale in 1912, purchasing a large piece of property and constructing a grand Craftsman-style home designed by noted architect Charles Shattuck. The house faced both Kenneth Road and Columbus Avenue. Mrs. Toll was a teacher who influenced the early Parent Teacher Association in 1914 and founded an early version of the Glendale Beautiful organization. Together the couple helped the fundraising effort to start the Glendale Symphony. The Eleanor Toll Middle School was named after her. (Courtesy of the Special Collections Room, Glendale Public Library.)

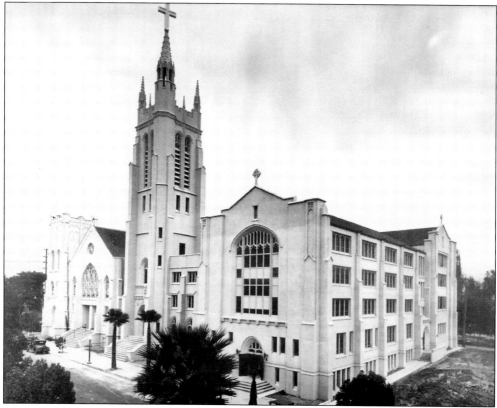

The First Methodist Episcopal Church at 134 North Kenwood included a five-story Christian Education Building built between 1928 and 1929 and designed by Arthur Lindley. One of the features of the building was the high tower with a lighted revolving cross. The 1917 building underwent a major renovation at the same time as the education building's construction. (Courtesy of the Special Collections Room, Glendale Public Library.)

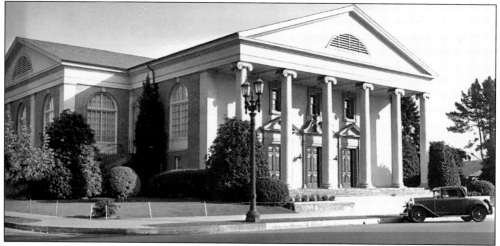

The First Church of Christ Scientist at 500 South Central Avenue opened for service in 1927 at a cost of $175,000. This photo was taken 10 years later. (Courtesy of the Special Collections Room, Glendale Public Library.)

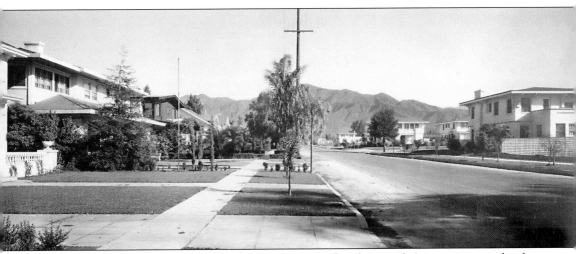

This photo, taken in 1928, shows the homes that once lined Central Avenue just north of Doran Street. Expanding commercial development caused this area to transition to businesses beginning in the 1940s. (Courtesy of the Special Collections Room, Glendale Public Library.)

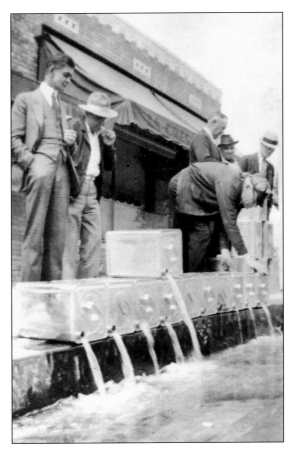

Crescenta Valley was close enough to Los Angeles to be convenient for illegal alcohol production, but still isolated enough for the moonshiners to hide out in the canyons. Stills and speakeasies thrived here in the 1920s, and occasionally someone got caught. Here Judge Dyer and County Constable Harris supervise the dumping of confiscated homemade whiskey from five-gallon containers in front of the Montrose Sheriff Station. (Courtesy of the Special Collections Room, Glendale Public Library.)

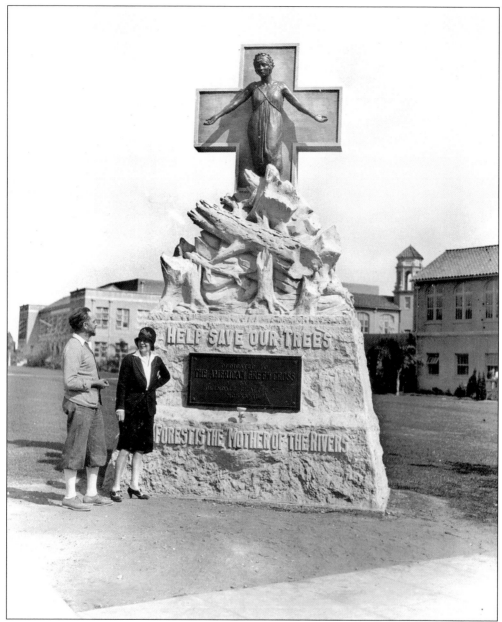

The Green Cross movement was an early conservation movement that drew attention to protecting the forests of America. The first chapter was founded in Glendale in the late 1920s and this sculpture of the "Statue of Miss America Green Cross," designed by Frederick Willard Proctor, was unveiled at a ceremony on May 23, 1928 on the grounds of Glendale High School. (Courtesy of the Special Collections Room, Glendale Public Library.)

This street corner containing the Wilson Building at San Fernando Road and Central Avenue represents the historical center of Tropico. The City of Tropico quickly lost its identity after the Glendale annexation in 1918. (Courtesy of the Special Collections Room, Glendale Public Library.)

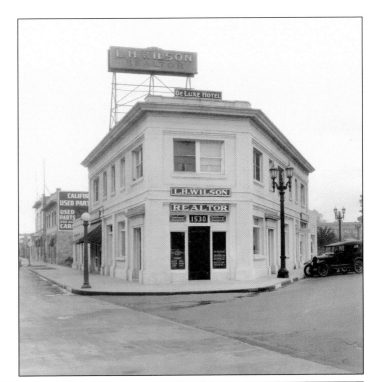

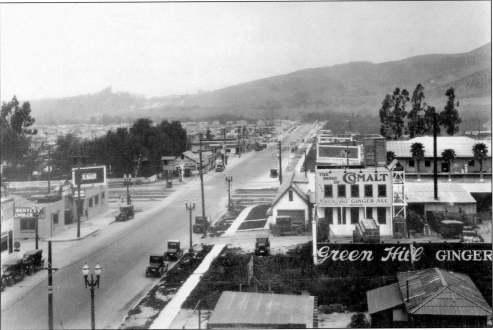

Looking west along Los Feliz Boulevard into Los Angeles and the Atwater area, Bentley Lumber is shown on the left next to the railroad tracks in this photo taken in 1926. The Comalt beverage company on the right was the site of a Prohibition bust when the Glendale Police Department raided the facility on March 22, 1928 and confiscated an assortment of bootlegger paraphernalia. (Courtesy of the Special Collections Room, Glendale Public Library.)

The widowed Mary Louise Brand, shown here c. 1928, lived out her life on the El Miradero estate following the death of her husband, Leslie C. Brand, in 1925 until her own death in 1945. According to the Leslie C. Brand will, El Miradero was willed to the City of Glendale for a library and park upon the death of Mrs. Brand. In the 1950s the city created Brand Park and a branch of the Glendale Library. (Courtesy of the Special Collections Room, Glendale Public Library.)

After the death of Leslie C. Brand of cancer in 1925, his former airfield remained vacant until it was sold for development. The El Miradero tract included homes designed by architect W.J. Jones in the Spanish style. The neighborhood became one of two early Glendale neighborhoods with requirements regarding architectural design. These boys are playing near the El Miradero estate, c. 1928. (Courtesy of the Special Collections Room, Glendale Public Library.)

Arthur Lindley, shown here c. 1921, was one
of the few noted Glendale architects of the
early period. Involved in many church and
commercial building designs in Glendale, he
came to Los Angeles in 1912 and by 1922 was
the architect of approximately 50 churches.
(Courtesy of the Special Collections Room,
Glendale Public Library.)

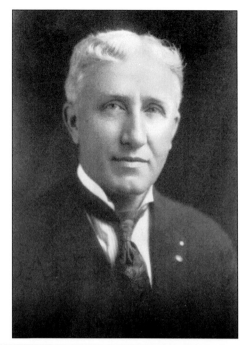

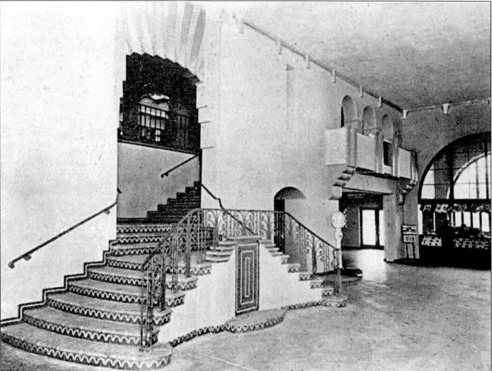

This photo of the ground floor interior of the Grand Central Air Terminal shows the blended
Art Deco and Spanish Colonial Revival design of the newly constructed building, including a
ticket booth, sandwich shop, coffee shop, and a large waiting room. (Courtesy of the Special
Collections Room, Glendale Public Library.)

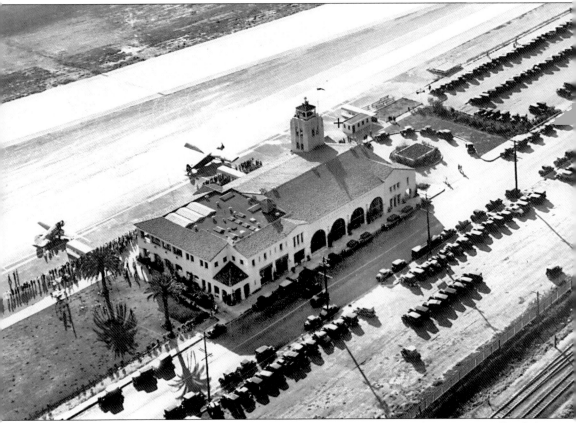

Grand Central was the first major airport in the Los Angeles area. Built in 1928, it offered the first transcontinental airline service between Southern California and New York beginning in 1929. This aerial view is from 1932. (Courtesy of the Special Collections Room, Glendale Public Library.)

Five

GLENDALE
BECOMES HOME
1930–1939

The stock market crash of 1929 impacted households and business ventures in Glendale, and for much of the early 1930s, Glendale, like other communities, suffered from the Great Depression. Some prominent local businessmen went bankrupt. In 1933 the Community Chest was formed to alleviate the hardships of the unemployed. Unemployment was so great that in 1933 the Glendale City Council adopted a controversial motion to dismiss female employees who had gainfully employed husbands.

The Works Progress Administration and other federal programs helped Glendale continue its development, but this time focused on community facilities needed for the growing city, such as the civic auditorium, the swim stadium, a new junior college, and a new city hall. The federal government also built a new, grand post office designed in the Second Renaissance Revival style completed in 1934.

Glendale's 1930 population of 62,736 grew to 82,582 by 1940. The 1930 population was largely Caucasian with the largest ethnic groups being Mexicans at 584 residents and Japanese at 408 residents. Most foreign born people were from Germany, England, and Canada. The Armenian foreign born population was 25 while the African American population was 38, mostly female. In 1930 Glendale was the fourth largest city in Los Angeles County and by 1940 became the third largest, passing Pasadena in size.

This era saw the community of Glendale come of age with the formation of a strong Glendale Symphony and other arts and cultural organizations not previously seen. The San Fernando Road area was becoming a strong industrial district. Glendale schools organized as the Glendale Unified School District in 1936 after the La Crescenta School District joined in 1931. Public works projects picked up after the mid-1930s and included widening Los Feliz Road, San Fernando Road, and completing the Chevy Chase Drive street and drainage improvements. With the many Hollywood movies of the era, the Glendale-formed board of censors was active.

A number of old and newly-established organizations were flourishing by the end of the 1930s. A 1939 city directory lists eight business clubs, 15 civic and service clubs, six improvement societies, 16 cultural and artistic clubs, four educational clubs, 22 patriotic organizations, seven political organizations, six professional societies, five religious clubs, nine welfare societies, 12 women's clubs, and three youth clubs. Churches also flourished in the 1930s, with new churches being built and those from the settlement era being substantially remodeled or enlarged. Many churches had their own organizations as well.

On January 1, 1934, the Montrose area in particular, and Glendale overall, suffered the effects of a large flood. Just after midnight on New Year's Eve a cloudburst sent a 10- to 20-foot-high wall of water and debris rushing down Pickens Canyon and across the valley floor. It smashed through the back wall of the Legion Hall, filling the room with mud and rocks, and finally broke through the front. Many of the people inside died, but some escaped through the front door and windows. The positive outcome of this tragedy was the ensuing construction of cement channels, debris basins, and innovatively designed bridges over the Verdugo wash to protect the area from future flooding.

A second high school was needed to serve the northern foothill area that developed greatly in the 1920s. Hoover High School opened in 1929. The Long Beach earthquake of 1933 brought some devastation to Glendale buildings. Many older schools were damaged, torn down, and rebuilt. The first Bob's Big Boy restaurant was founded in Glendale in 1936 by Robert Wian, a longtime Glendale resident who became mayor in 1948.

After 1935 residential development on lots subdivided in the 1920s picked up speed and more people started to make Glendale their home. Community parades down Brand Boulevard and Broadway were popular events that brought the whole city together and included the Halloween Parade, the Armistice Day Parade, the Memorial Day Parade, and the Community Christmas Parade. By the end of the 1930s Glendale became home.

This cover illustration from the 1931 issue of *Glendale Your Home* from the Glendale Merchants Association provided a pleasant marketing effort at promoting the city. The Glendale Merchants Association started in 1913. (Courtesy of the Special Collections Room, Glendale Public Library.)

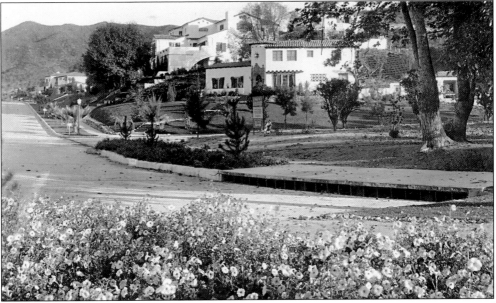

This view looking up Royal Boulevard from Mountain Street provides a picturesque image of suburban Glendale with Spanish architecture, gently rolling hills, and pleasant landscaping. (Courtesy of the Special Collections Room, Glendale Public Library.)

Charles Bowden built this popular swimming pool and picnic area in Montrose in 1929 with a Native American theme in mind. Built down in a canyon of the San Rafael Hills to the east of Montrose, it actually used a natural spring that flowed there as part of the pool's water source. Shown here is the arched entrance to the Indian Springs pool and picnic area. (Courtesy of the Special Collections Room, Glendale Public Library.)

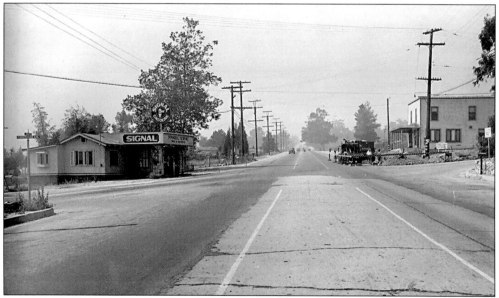

In 1930 Michigan Avenue became Foothill Boulevard serving as an east-west highway across the northern foothills. This photo shows Foothill Boulevard and Pennsylvania Avenue as they appeared in 1936. (Courtesy of the Special Collections Room, Glendale Public Library.)

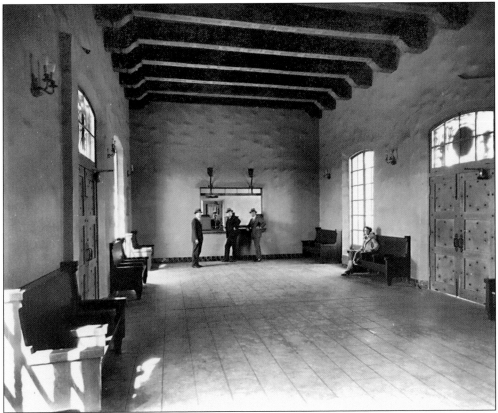

The interior of the new Southern Pacific Train Depot, completed in 1923 and shown here c. 1935, was located adjacent to the old Tropico Depot. (Courtesy of the Special Collections Room, Glendale Public Library.)

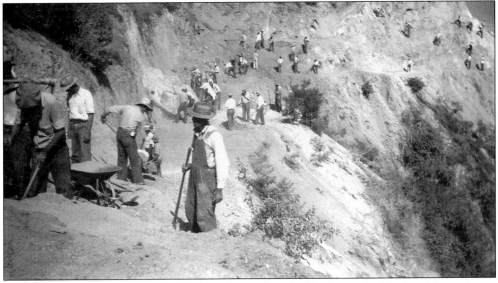

In 1934 road building for the new Las Flores fire road reached high into the Verdugo Mountains up beyond 2,000 feet elevation. (Courtesy of the Special Collections Room, Glendale Public Library.)

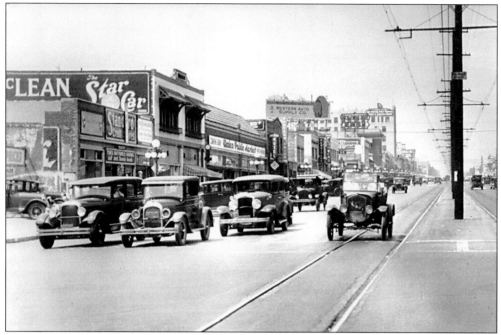

This view of the west side of Brand Boulevard, photographed around 1930, looks north on Brand Boulevard from Colorado Boulevard. (Courtesy of the Special Collections Room, Glendale Public Library.)

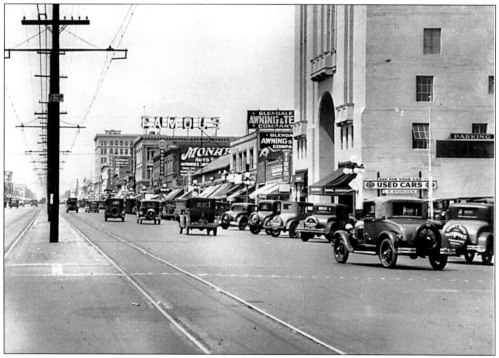

This is the east side of Brand Boulevard looking north up Brand Boulevard from Colorado Boulevard around 1930. (Courtesy of the Special Collections Room, Glendale Public Library.)

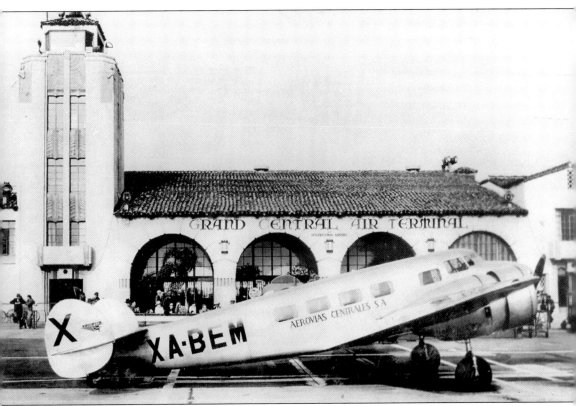

The first international passenger and mail service was offered out of Grand Central to Mexico City in 1934. (Courtesy of the Special Collections Room, Glendale Public Library.)

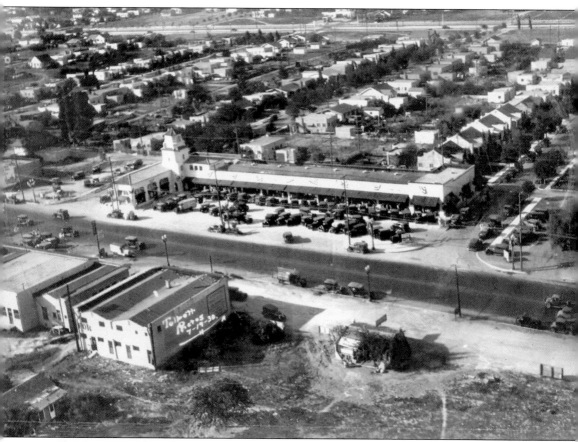

The Aurora Market, shown here in 1930, was one of the many drive-in markets in Glendale during the 1920s and 1930s that combined shopping into one central area with convenient parking. The distinctive tower was designed to attract motorists from various directions. The Aurora Market was located on San Fernando Road at Davis Avenue. Glenoaks Boulevard is seen in the background. (Courtesy of the Special Collections Room, Glendale Public Library.)

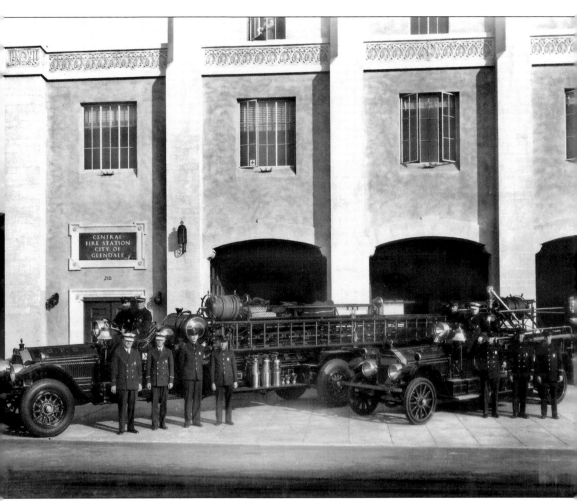

Fire service began in 1907 with a horse-drawn wagon and 25 volunteers. By 1931, a new central fire station for the Glendale Fire Department was built as Station 21, a paid force was fully employed, and a new fire truck carried the latest fire fighting equipment. (Courtesy of the Special Collections Room, Glendale Public Library.)

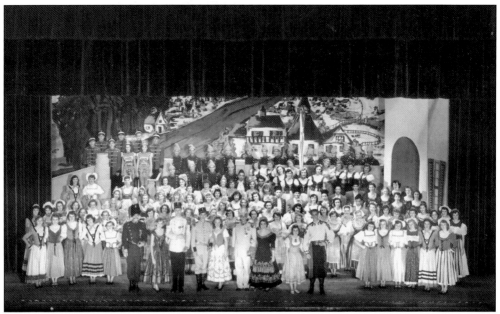

On February 20, 1931, the students at Hoover High School put on a variety show production close to professional quality. The high school was built in 1929 and provided students with a grand auditorium. (Courtesy of the Glendale Unified School District.)

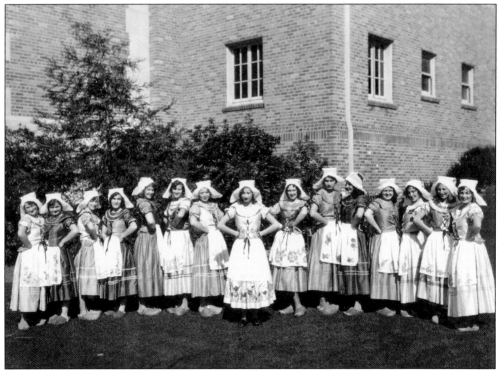

As part of the variety show, "Hoover Girls" pose outside the auditorium before the show dressed in their Dutch costumes, complete with wooden shoes. (Courtesy of the Glendale Unified School District.)

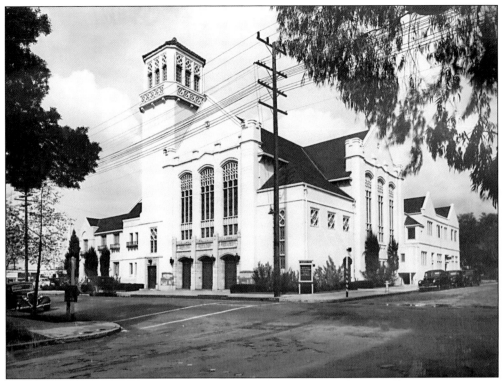

Founded in 1904 on the second floor of the store building at Glendale and Wilson Avenues, the First Baptist Church relocated to the northwest corner of Wilson Avenue and Louise Street. The original wooden chapel built in 1912 can be seen to the right of the Gothic-style Spanish tower constructed in 1926. (Courtesy of the Special Collections Room, Glendale Public Library.)

The Glendale Presbyterian Church grew rapidly, purchasing the property at the northwest corner of Harvard Street and Louise Street in 1920. Groundbreaking was held on Easter Sunday 1922 and the church was dedicated on December 30, 1923. The sanctuary and tower stood proud until the 1971 earthquake forced demolition. A new church was built and remains at this same site today. (Courtesy of the Special Collections Room, Glendale Public Library.)

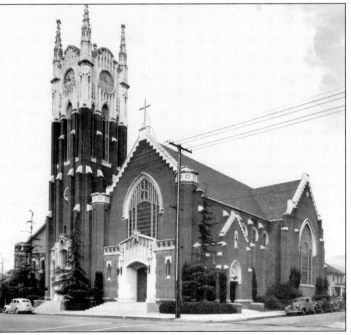

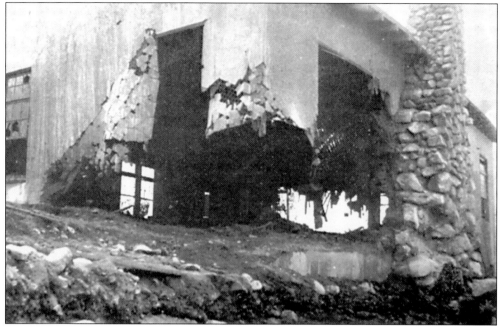

This photo shows the damage to the American Legion Hall in La Crescenta after the 1934 flood. The building was a refuge center for those forced out of their homes by prolonged rainstorms. The Historical Society of the Crescenta Valley has erected a monument on this site. (Courtesy of the Special Collections Room, Glendale Public Library.)

The flooding was so extensive that it lifted the Pacific Electric tracks on North Brand Boulevard. (Courtesy of the Special Collections Room, Glendale Public Library.)

Glendale High School moved off of its second campus by 1929, and a new junior college moved in. The Long Beach earthquake of 1933 caused Glendale Junior College students to move into tents and bungalows until their new campus was built. (Courtesy of the Special Collections Room, Glendale Public Library.)

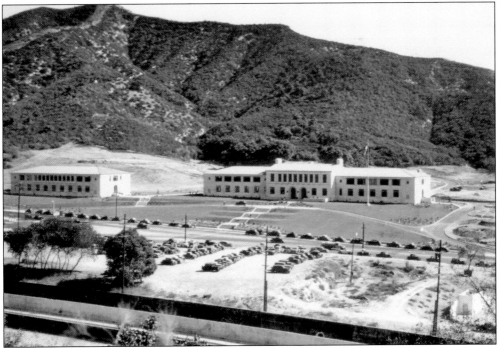

The new campus of the Glendale Junior College opened in 1937 offering vocational, academic, and certificate programs for free. (Courtesy of the Special Collections Room, Glendale Public Library.)

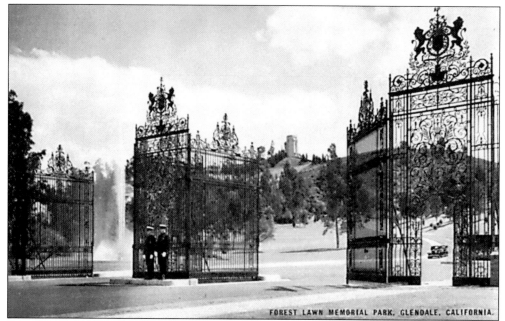

Forest Lawn established a new entrance with the installation of a large ornate gate designed in the early English Renaissance style. It was claimed to be the largest in the world at the time, larger than the gates at Buckingham Palace in London. The name of Forest Lawn Cemetery changed in this period to the Forest Lawn Memorial Park. This photo dates from 1932. (Courtesy of George Ellison.)

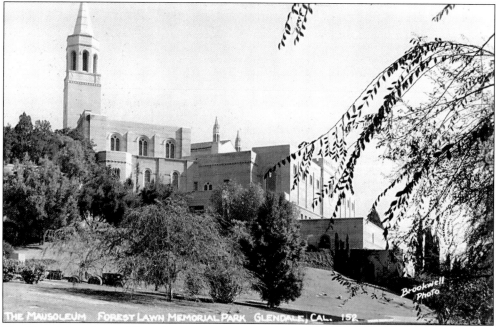

The Great Mausoleum of Forest Lawn was constructed in terraces with the first five shown in this c. 1932 photograph. (Courtesy of the Special Collections Room, Glendale Public Library.)

Shirley Temple sang and danced "The Good Ship Lollipop" in the 1934, 20th Century Fox film *Bright Eyes* as they taxied down the runway past the Glendale Grand Central Air Terminal. (Courtesy of the Special Collections Room, Glendale Public Library.)

The National Breakfast Club of Glendale was one of many businessmen's clubs established in Glendale at the time. This photo was taken in 1935 in front of the breakfast club's meeting place at 404 South Brand Boulevard. John Calvin Sherer, seated in the front row third from the left, provided Glendale citizens with accounts of the pioneer days. (Courtesy of the Special Collections Room, Glendale Public Library.)

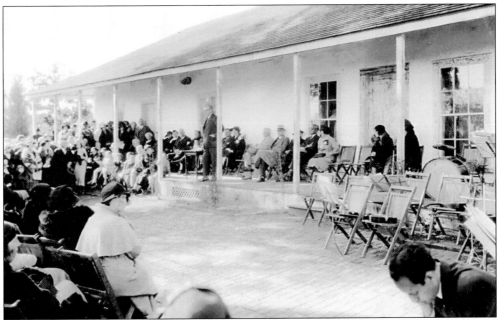

This photo shows the dedication ceremony on March 10, 1935 following the preservation and restoration of the Sanchez Adobe, which had been threatened with demolition and tree removal due to advances from a new development in the neighborhood. The efforts of a small group of women, along with the Junior Green Cross and the Glendale Historical Society, were instrumental in saving the property, which the city purchased for a park and museum. The effort was considered one of California's earliest historic preservation actions. (Courtesy of the Special Collections Room, Glendale Public Library.)

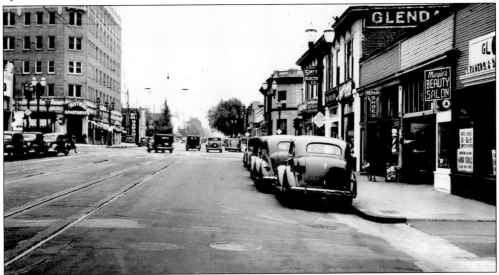

This 1932 photograph of East Broadway looking toward Glendale Avenue shows the Hotel Glendale on the left and the two-story shop building on the right that today is the location of the county courthouse. The east-west railway once provided transportation to Eagle Rock, but by 1932 ended at Chevy Chase Drive. (Courtesy of the Special Collections Room, Glendale Public Library.)

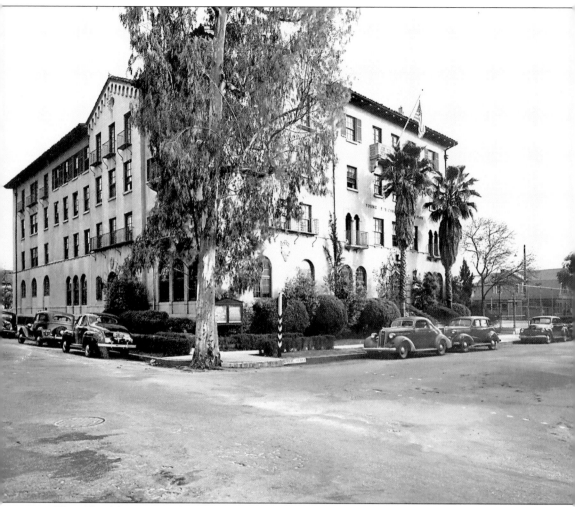

The Glendale YMCA, shown here in 1938, was founded in 1919. A massive fundraising drive brought in enough money in 1926 to construct one of the most successful establishments of Glendale. Located at Wilson Avenue and Louise Street the building is an excellent example of Spanish Colonial Revival architecture and was originally designed with an open-air courtyard in the center and an underground swimming pool. Upper rooms were constructed for housing. The building still houses the YMCA today. (Courtesy of the Special Collections Room, Glendale Public Library.)

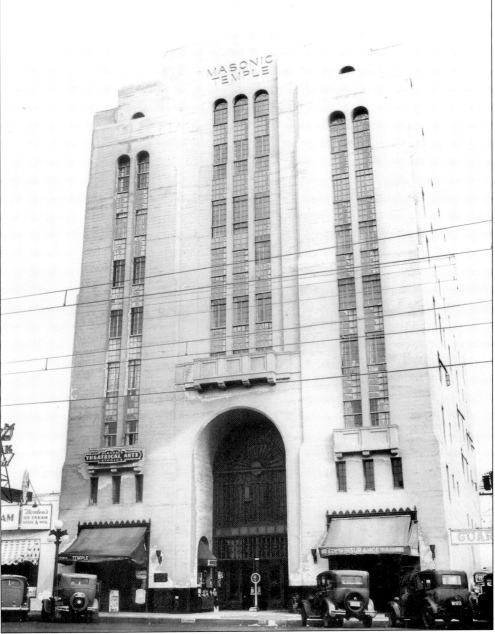

This Masonic Temple, photographed in 1938, was the third home of the Masons and was designed by architect Arthur Lindley. Its overzealous design reflected the extremes of the late 1920s era while its construction was made possible in 1928 by combining the assets of various Masonic organizations. The Masons used the building until the organization built a new, smaller home on Maryland and California Avenues in the 1950s. The ground floor housed an auditorium, later used as a movie house. (Courtesy of the Special Collections Room, Glendale Public Library.)

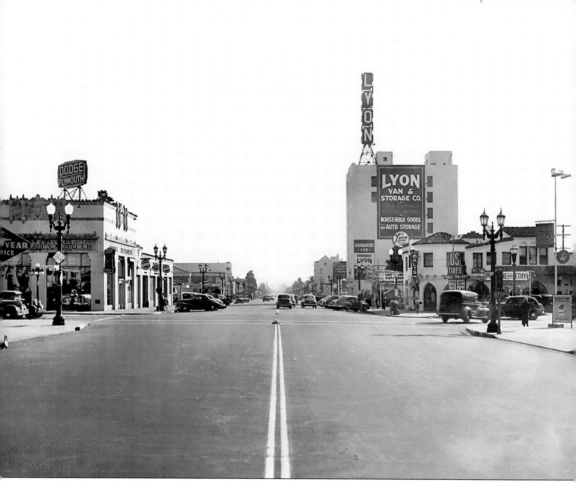

This image is of Central Avenue looking south, with Colorado Boulevard intersecting it in the foreground. The El Bonito market is seen on the right and the Dodge Plymouth dealership on the left. The dominating Lyon Storage building is visible in the background. (Courtesy of the Special Collections Room, Glendale Public Library.)

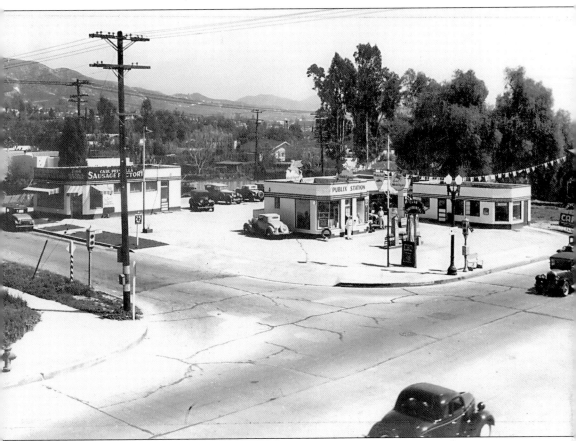

This intersection of San Fernando Road and Sonora Avenue in 1937 shows the Publix Service Station providing fuel and auto service to motorists traveling along the old state route before any freeways were built. Behind the service station is a sausage factory. (Courtesy of the Special Collections Room, Glendale Public Library.)

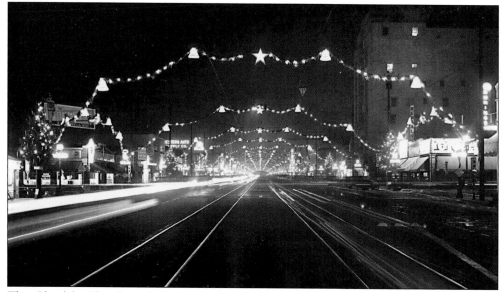

The Glendale Chamber of Commerce began the tradition of stringing lights across Brand Boulevard to bring Christmas cheer, as shown in this photo of the Tunnel of Lights taken in1938. The lighting was made possible when the center Brand Boulevard streetcar poles were removed and new poles where placed on both sides of the road. This view shows the lights looking north just below Colorado Boulevard. (Courtesy of the Special Collections Room, Glendale Public Library.)

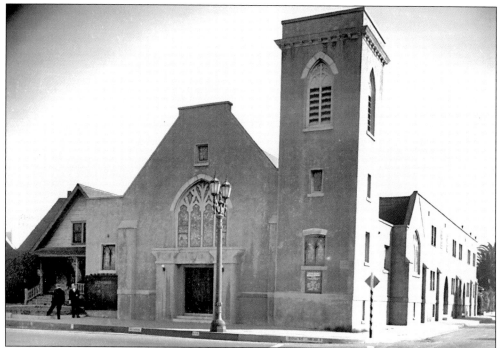

The Central Methodist Episcopal Church, shown here in 1939, began in 1884 as the Riverdale M.E. Church and later became the Tropico Church. It moved to the corner of Central and Palmer Avenues in 1913. (Courtesy of the Special Collections Room, Glendale Public Library.)

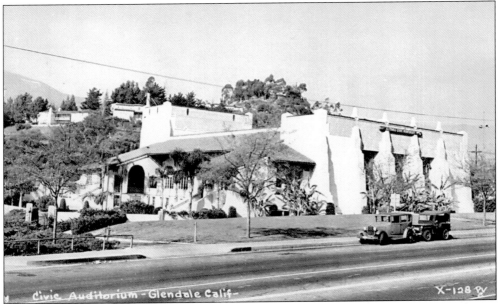

The new Glendale Civic Auditorium on Verdugo Road, shown here c. 1939, was built as a Works Progress Administration project in 1938, containing a large upper ballroom/auditorium for dancing and stage entertainment. The facility held up to 3,000 people. City-sponsored dances with big name bands were held in the pre-war years and drew large crowds. (Courtesy of the Special Collections Room, Glendale Public Library.)

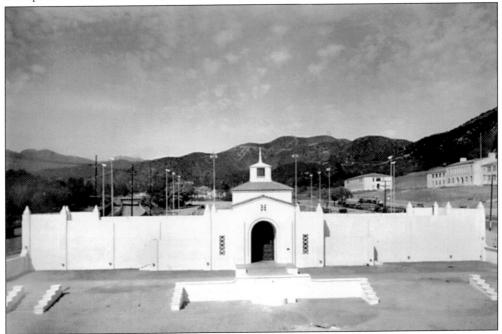

The Verdugo Swim Stadium, built in 1937, was a public swimming pool that contained an outdoor Olympic-size pool and served as an integral part of the civic auditorium providing community facilities and recreation to Glendale residents. The project was another Works Progress Administration facility. (Courtesy of the Special Collections Room, Glendale Public Library.)

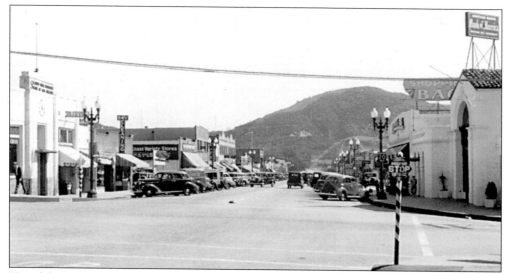

Honolulu Boulevard was a busy area in the 1930s as evidenced by this 1938 photograph of the Montrose business district, which shows the area looking east across the intersection of Ocean View Boulevard toward the San Rafael Hills. It was around this period that Montrose merchants formed a Business Improvement District, in which all businesses paid into a common fund for improvements that were used to turn the area into a unified shopping district. (Courtesy of the Special Collections Room, Glendale Public Library.)

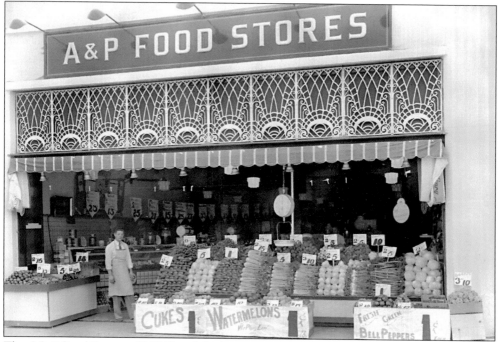

The A& P Food Store at 2200 Honolulu Avenue was typical of the open front stores common during that era, although many were being phased out by the time this photograph was taken in 1939. Like most of the early brick buildings in Montrose, this structure is still used as a retail store today, but with a much different front façade. (Courtesy of the Special Collections Room, Glendale Public Library.)

The Glendale Federal Savings and Loan Association was started in 1934 by Joe Hoeft as the First Federal Savings and Loan Association in a small, rent-free office on east Broadway with only $5,600. By 1958, it grew to be the tenth largest federal savings and loan association in the United States and second by 1968. This photo shows the bank at its 118 North Brand Boulevard location in 1937. (Courtesy of the Special Collections Room, Glendale Public Library.)

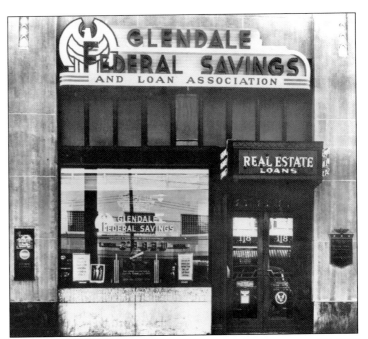

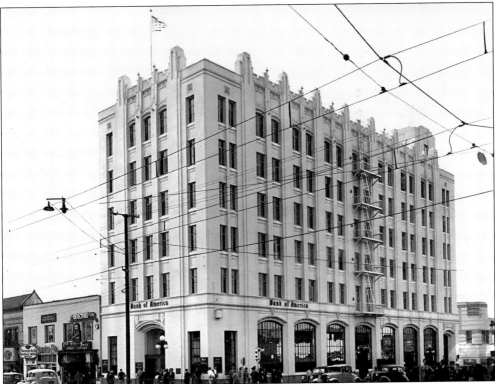

This six-story structure on the southwest corner of Brand Boulevard and Broadway was built in the 1920s by the Los Angeles Trust and Saving Bank and changed names a few times before becoming Bank of America as shown here. The bank was on the ground floor and offices were located on the upper floors. (Courtesy of the Special Collections Room, Glendale Public Library.)

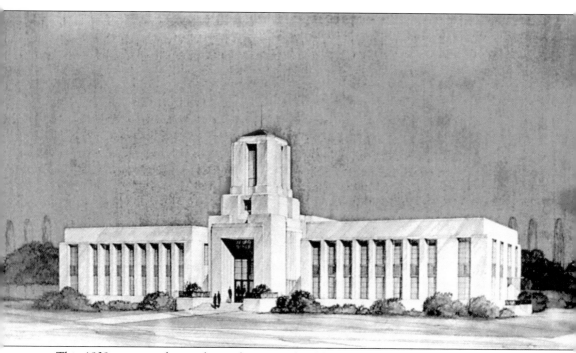

This 1939 artist rendering shows the new Glendale City Hall, which was designed by local architect Alfred Hansen and built in sections between 1940 and 1942 with the design reflecting a classical and restrained sense of style for the largely conservative community of the 1930s. The east wing housed Glendale's first city hall retaining part of the old structure. Construction was made possible with federal funding from the Works Progress Administration. (Courtesy of the Special Collections Room, Glendale Public Library.)